ABANDONED CONNECTICUT

FIRST WORLD WASTED

CHRISTINA E. COLE

AMERICA
THROUGH TIME®
ADDING COLOR TO AMERICAN HISTORY

America Through Time is an imprint of Fonthill Media LLC
www.through-time.com
office@through-time.com

Published by Arcadia Publishing by arrangement with Fonthill Media LLC
For all general information, please contact Arcadia Publishing:
Telephone: 843-853-2070
Fax: 843-853-0044
E-mail: sales@arcadiapublishing.com
For customer service and orders:
Toll-Free 1-888-313-2665

www.arcadiapublishing.com

First published 2021

Copyright © Christina E. Cole 2021

ISBN 978-1-63499-360-9

Typeset in Trade Gothic 10pt on 15pt
Printed and bound in England

CONTENTS

ACKNOWLEDGMENTS

This book is dedicated to all, present and past, who took the time to live, explore, and be adventurous with me in all the grimy, falling down, rickety, asbestos- and tick-filled, tetanus, and death-worthy locations.

I dedicate these pages to David Graham, who not only kept me alive during our outings but during cancer as well. If it were not for you, David, neither this book nor I would be here today.

Thank you to my editors and publisher, Fonthill Media.

To The Bravery, who have been the soundtrack in my mind since my mom passed. Your words that I could not express play endlessly in my head.

Please note that some historical materials may contain offensive content and was obtained by a lot of old timers and locals in addition to cited sources.

FOREWORD

Some cultures—and individuals—believe that taking a photo of a person captures a piece of that person's soul. Some psychics and mediums claim (and some have demonstrated) that a person's photo carries both information and a sort of marker that the person is alive or dead. The same can be said of photos of buildings and other structures.

While buildings are not people, we have all experienced those places that feel more alive, or at the very least, have some emotional "vibes" we can feel. Buildings with lots of human activity seem to project the emotions and even a sense of the activities that occur within. They seem alive.

When people leave the building empty, altogether abandoning it for whatever reason, one might say that place is "dead." Yet the impressions of emotions and activity (from the living who are no longer there) seem to linger, often for decades. To many, such places are "haunted" even though there may not be human spirits present.

If a photograph can capture information, even the sense of life of a person that some can perceive, what about photos of places that are or were centers of lots of activity and emotion?

Of course, the photo has to be a good one to capture the place's essence (the same goes for people's photos). "Good" is, of course, a subjective assessment. However, I believe you will find "good" is not a strong enough label for Christina Cole's photography in this book.

I am certainly not a psychic or medium, though as a parapsychologist, I have worked with many over the years (and uncovered my fair share of phonies as well). Yet I have investigated and studied places that seem to exude emotions almost anyone can pick up (and felt the "vibes" of homes when house-hunting). Some areas seem to have such a strong "vibe" that you would almost swear there is a true "Spirit of Place."

For example, I have done lots of work over the years studying the reported activity aboard the U.S.S. Hornet Aircraft Carrier Museum in Alameda, California. The *Hornet*,

which has appeared in numerous news, documentary, and reality show segments about haunted places, has a large number of first-hand accounts of encounters with ghosts. Yet what is truly interesting about it is the sense that the *Hornet* has its own "spirit"—one can almost feel the ship itself, ghosts or no ghost. Photos of the vessel from the parking lot almost give one the impression she is smiling at you.

The "feel" of the place is evident in the photos of this book's locations. Christina Cole has genuinely captured the essence, the "Spirit" of the buildings, in her exceptional photography. By providing the sites' history, covering when they were inhabited and active, to their "afterlife," she has done a phenomenal job providing you with a true sense of these places.

I have not had the opportunity to visit any of the locations myself, but I do truly get a sense of them from Christina's photos. I hope you do, too.

Loyd Auerbach

Loyd Auerbach, MS, is a world-recognized paranormal expert/parapsychologist with a graduate degree in parapsychology and thousands of media appearances. He is the co-author of the new paranormal mystery novel *Near Death: A Raney/ Daye Investigation* and the author or co-author of nine paranormal books, including *Psychic Dreaming, Mind Over Matter, ESP Wars: East & West, The Ghost Detectives: Guide to Haunted San Francisco*, and the classic *ESP, Hauntings, and Poltergeists*. He is president of the Forever Family Foundation (since 2013) and director of the Office of Paranormal Investigations (since 1989). A professor at Atlantic University and National University (formerly JFK University), Loyd teaches online parapsychology courses through the Rhine Education Center. He is vice-president of the Board of Directors of the Rhine Research Center and serves on the Windbridge Research Center's advisory board. He is a past president of the Psychic Entertainers Association. Besides all that, he performs as professional mentalist "Professor Paranormal" (and occasionally as a professional chocolatier).

Watch him on Netflix in the recently launched series *Surviving Death*. Other media appearances have included *The New Thinking Allowed* (YouTube), *The UnXplained,* ESPN's *SportsCenter*, ABC's *The View, Oprah, Larry King Live, Coast to Coast AM*, and many hundreds more.

Twitter: @profparanormal
YouTube: youtube.com/loydauerbach and youtube.com/profparanormal
Email: profparanormal@gmail.com

INTRODUCTION

The days of scaling a 6-foot wall to a warehouse window in the snow are gone. It is possible that sliding down a cliff on my muddy buttocks is a distant memory. White water rafting on my knees over a ledge and climbing up with one arm would now surely be a death sentence. Swimming with alligators—geographically impossible, for now—is definitely a no-go for the future. SWAT teams, guns, and police dogs could happen, but I am certainly aiming for a more permissive approach nowadays. The crunch of an actively decaying floor makes my heart pound just like the day I fell through one. Once, I could have sworn a ferocious army of zombies after an open wound tried to get at me through a boarded-up door, though it was probably only one angry guy. Chased into a morgue's second-story window might now be met with the enthusiasm of ticks while hiding in the tall grass. These pitfall explorations all came with a price, whether it be an injury to leg and limb or a three-hour conversation with a security guard about history. They also came with a reward; seeing some of the most fantastic architecture in New England and preserving just a stitch of it for our future.

So many buildings come and go in these times. No thought is given to tearing down beautiful, ornate, and stimulating architecture, only to replace it with unimaginative warehouses, churches, and shopping malls. The talent that it took to imagine these impressive structures and put them together is long lost on the pop-up house architects of today. One fascinating aspect of our culture is being drowned out by identical dwellings one after another, flat prefab apartments born from creative starvation.

Also, they do not want you to see the waste toppled over in a remaindered building—beds, chairs, tables, and computers, nearly anything you can think of. Unlike the south, where it disintegrates in no time, the northeast preserves it like a frozen statue of guilt. Indeed, they do not want to put in the effort to donate or refurbish a building when a big bid on development makes their pockets even deeper. So the

years go by, and nothing changes except the graffiti on the walls and eventually a visiting bulldozer.

Dirty, wet, and covered in asbestos, mud, and mold has been my Connecticut existence. Despite the mandatory lockdowns and quarantines of COVID-19, the one thing still accessible to us all is the outdoors. In these great outdoors sit plenty of empty buildings to explore. The grime suits me just fine. There is a particular sort of freedom to roaming alone in a building by yourself—something you cannot get every day as Connecticut's people to space ratio is really pushing its limits. I would even go as far as to say it is healthy. Cut out all the voices and the continuous communication and time out your mind—what better way to do this than strolling through the empty?

The Urbex community was hitting its peak in 2010–2013. Facebook groups starting popping up, and Instagram was just starting to get going, which would later become a hub for all things abandoned. Meeting people from all over the United States and seeing their amazing photos, I heard myself often say, "I want to see that."

Social media showed us that Connecticut and New York always seemed to have more sprawling decay than other places in the United States—undoubtedly because of the state's age and, of course, more people being squished up here in this tiny span of land.

The friend-making and fascination came together, and I could visit and explore some of these beauties. Eventually, the opportunity presented itself to relocate to Connecticut permanently, and I stayed, allowing me to watch the rise and fall of quite a few structures.

Between these pages, you will find some of the more widely known decay representatives—popular in the early days of the hobby but long gone now, fallen to the bulldozers and bureaucratic nonsense. Some will be new abandonments, though it will not be long before they are removed from history as well. It is unfortunate; the structures do not last long in their urban state, but moving and shaking in old Connecticut real estate is where the money is at. Here, they are preserved for history's sake.

1

SUNRISE RESORT, MOODUS

"So Many Friends and None of Them Mine"

My first exploration in Connecticut was Sunrise Resort. Born in 1916, it ran easterly on the Salmon River. The 149 acres were for more than a century known under various names such as the "Elm Camp," "Ted Hilton's Hideaway," the "Frank Davis Resort," and in later years "Sunrise." Its popularity was touted across state lines—enough to run a train line from New York to East Haddam to accommodate the consistent 500-plus summer-loving families and guests. Here you could get away from the bustle with dancing, skiing, horseback riding, sailing, themed weeks, and lavish dinners. The year 2008 marked the final decline from what guests referred to as an "outdated relic, old and musty, in disrepair" to final abandonment.

The state had plans to turn the retreat into a home for people with disabilities. Sadly, this never came to fruition, and the site fell well beyond saving. Overgrown, vandalized, and forgotten, D.E.E.P. stepped in, purchased the property for $5 million, and morphed it into a state park.

Walking, struck by the beauty of this place, still standing, covered silently in the snow, was only outweighed by the vision of waste that accumulated as it lay to rot. Staggering amounts of needful things that most people would have to pay dearly for in regular life were stockpiled on the grounds—all things a struggling young mother does not have the money for but would love to give to her child, like a desk to work off for school. Most of the items would eventually find their way into a landfill.

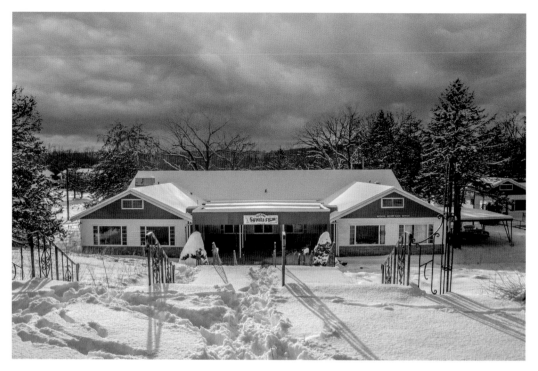

Welcome to Sunrise Resort; this would have been your first stop when you arrived—the lobby, check-in, and all essentials—the doorway to everything fun.

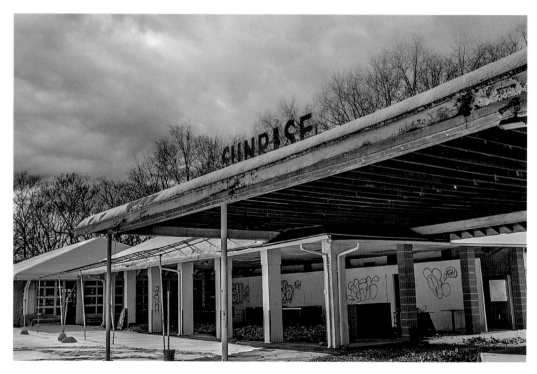

This building had retro-looking fiberglass picnic tables in bright colors for people taking a break from gaming and sport that wanted a snack.

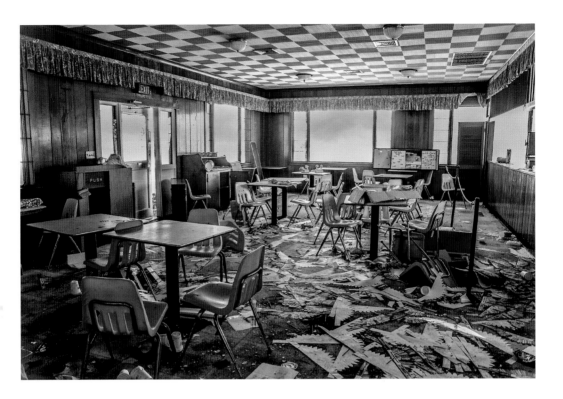

Above: Knotty pine paneling bordered in sparkly tinsel streamers still decorates the snack bar walls. Few menu items are left on the dowel letterboard; now, it resembles sex education instead. The floor is littered with Sunrise Native American paper headdresses and cups resembling a food fight.

Right: A human-height blender and bread rack still stand in the baking area.

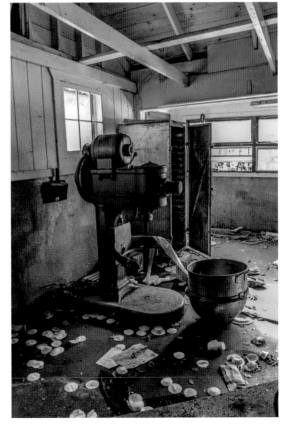

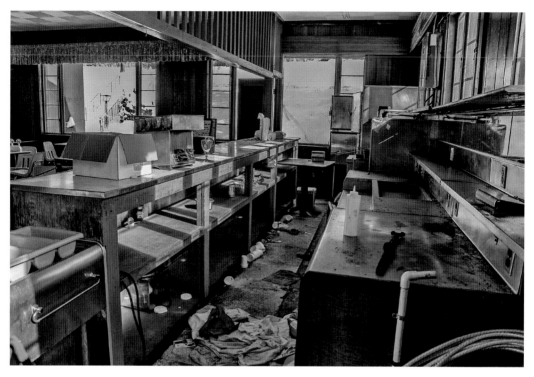

An old container of Jacob's Coffee sits across from the fryer. Napkins and a chef's jacket litter the greasy floor. It is like someone threw their jacket down and just walked out.

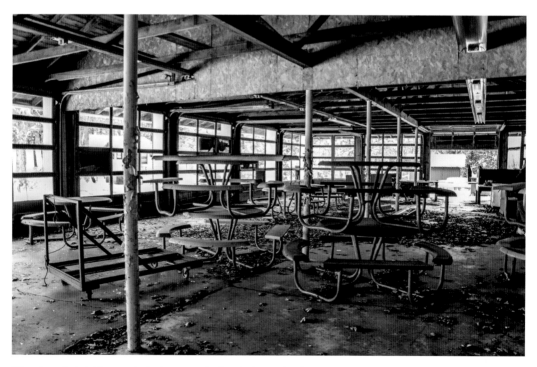

Fiberglass picnic tables are stacked upon each other in the outdoor bay meal area like they know they will never be used again.

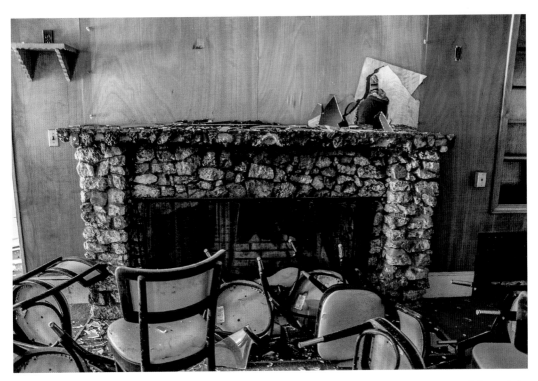

Either this is the jitterbug gone wrong or guests had a smashing good time. We even found one of these chairs sitting alone in the middle of the frozen Salmon River.

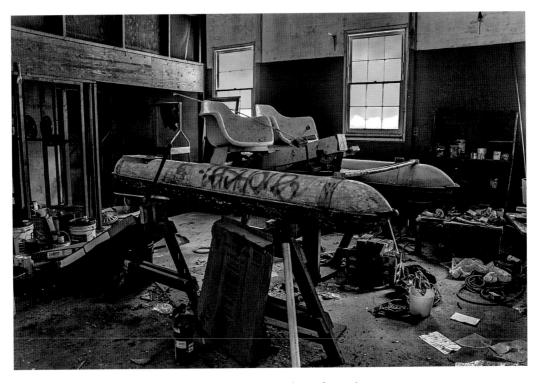

A pontoon boat waits patiently forever in the garage work area for repairs.

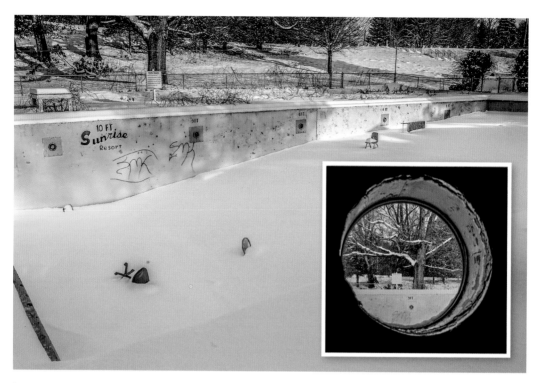

No horseplay—the 10-foot Sunrise Resort pool holds snow-covered chairs instead of water and swimmers.
Inset: Portholes look out into the pool area, where guests can watch swimmers practice being mermaids.

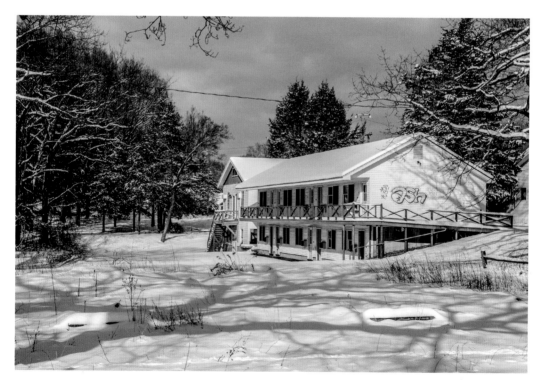

This is the side view of the camper's quarters and apartments.

2

UNDERCLIFF SANATORIUM, MERIDEN

"SLOWLY I'M LOSING YOUR FACE"

Undercliff Sanatorium, located in Meriden, CT, underneath South Mountain and proximate to Hubbard Park, was established in 1910 under Undercliff State Hospital. As with most of these hospitals, it would go through various calling cards, from "Undercliff Sanatorium" to "Undercliff Mental Health Center." The facility stayed in operation until 1976. The complex's initial purpose was to house children with tuberculosis and a variety of pox-related diseases.

In 1939, it would open its doors to its first adult patients. The 1950s saw its adolescent children relocated to Seaside Sanatorium in Waterford, eventually decommissioned in 1976 due to looming accusations of patient abuse, though the evidence is slim. The remaining patients moved to cottages on the property, and the very last inhabitant was discharged in May of that year.

In the years leading up to Undercliff's demolition, rumors floated of laughing and crying children haunting the building and chilling stories of cross-dressing cannibal serial killer Haddan Irving Clark. The draw was rumored somewhere on the 40-acre property; he had buried one if not some of his victims here, though a body was never located by authorities.

Undercliff continued to keep the lights on as some parts of the buildings were used for different government departments, from child services to the state police. You could walk along one hall and it would be unchanged, then the next section's roof had caved in, the floor covered in moss and snow, with a constant maddening drip. One could never tell if someone was talking or the babbling sound of silence, and water was playing tricks on your mind. I can personally attest to the footsteps in the halls. I cannot say if it was indeed the ghosts of children running from the staff or a current official coming in for storage, but there was never a sign of someone physically about the floors.

Demolition of Undercliff started in October 2013 to make way for a juvenile courthouse.

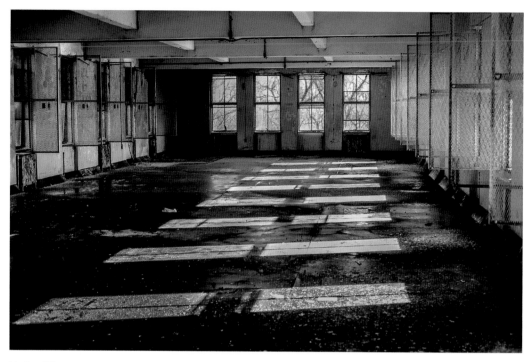

Undercliff's communal sick room. Beds are lined underneath every caged window as one big hospital ward.

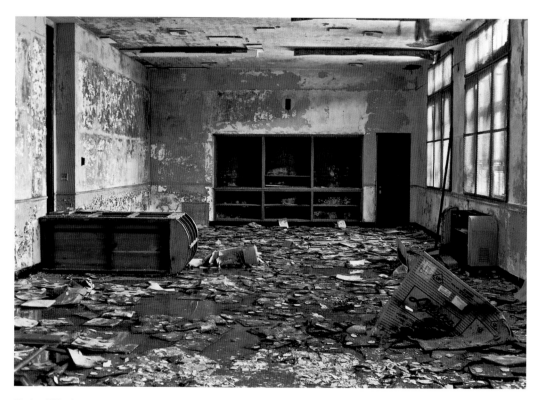

Undercliff's day room—communal exercise space that used to have a gymnastic horse and rings. Keeping patients active was a significant benefit in their recovery and growth.

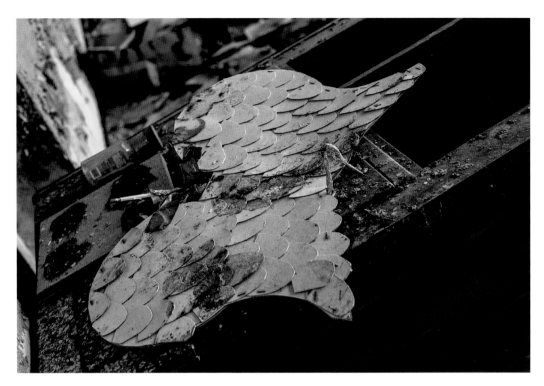

Undercliff presents "An Angel Lost its Wings." Makeshift crafting and production were also part of the sanatorium's life.

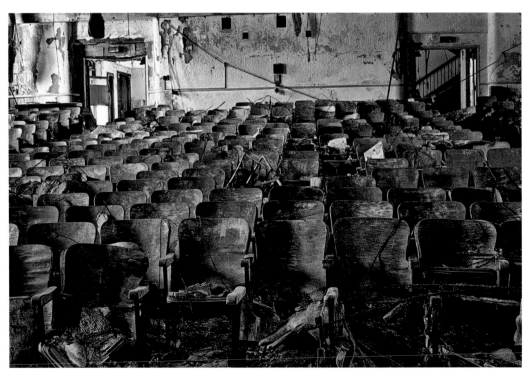

Undercliff's theater—rotting wood seats peeling apart in the elements. By this point, that theater had a gigantic hole in the roof where snow and rain would cover the stage and seats.

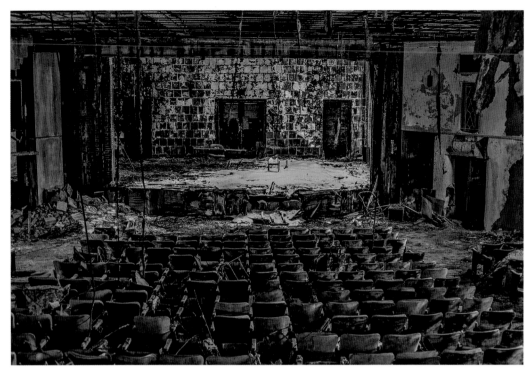

A theater view as snow covers the star center stage.

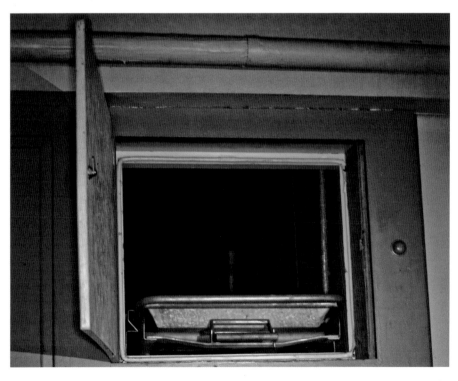

The morgue—strange light seeps through the cracks, illuminating the metal trays and cabinet used for cold storing bodies of the sanatorium.

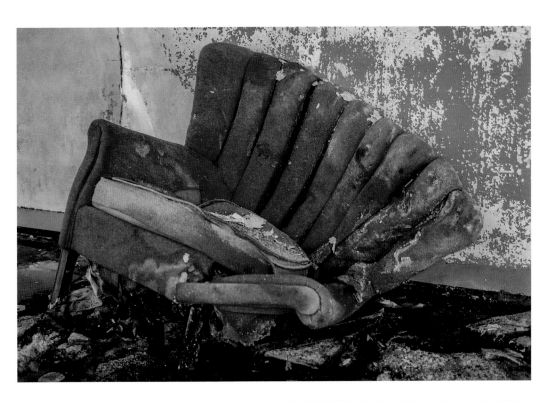

Above: An Art Deco red velveteen chair crumbling beneath the elements—perhaps an indication that Undercliff may have been decorated ornately instead of the sterile mental hospital idea.

Right: Never-ending hallways of natural light and color tunnel silently down the hospital floors.

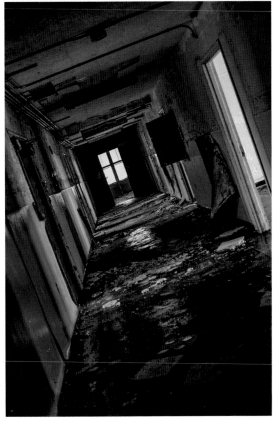

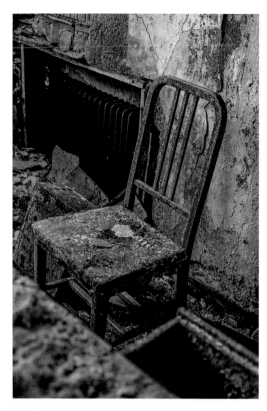

Undercliff's ward check-in desk. Crusty and rusty, covered in plaster, rotting, moist ceiling tiles, and mold, the desk sits as if it still waits for the next visitor to approach—the final position acts as a reminder of the occupant's last post.

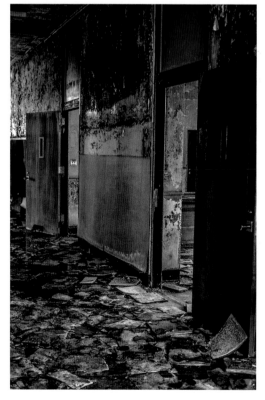

Waste slushing through the sopping asbestos tiles to the unlocked solitary doors with their slit windows and slanted views—some of it shining ice and some of it bacteria-infested water, both heavy with the weight of it slowly working away at the floor beneath.

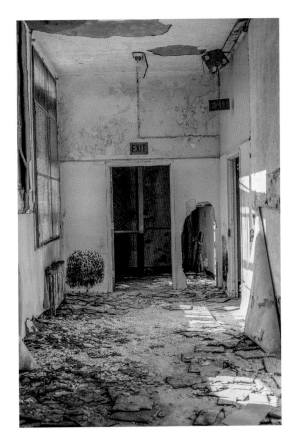

Right: Black mold crawls up the pastel walls that lead to the caged transport hallways behind it. Scrappers have already started to work the entry wall and electrical wires for copper to sell, accelerating the structural damage.

Below: Bulldozers scrape at the earth of demolished Undercliff, pushing it into neat piles of brick and into containers for removal.

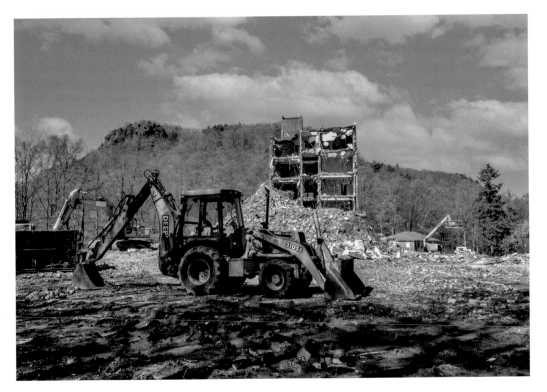

3

NORWICH HOSPITAL FOR THE INSANE, NORWICH

"I WISH I NEVER KNEW YOU AT ALL"

Norwich Hospital was established in 1904 and eventually closed its doors in 1996. Situated between Preston and Norwich, it occupied over 900 acres with around thirty buildings. The hospital treated patients with mental illness, dependencies, geriatrics, and (for eight years) tuberculosis. The criminally insane, with over 700 convicts, were housed in the notorious maximum-security Salmon Building. Patients were separated by male and female, by north- and south-lettered wards, later renamed in honor of founders from the American Psychiatric Society.

When erecting a new building, one would close, contributing to an unusual amount of beautiful Kirkbride architecture and vacant vagrant inhabited buildings reputed haunted. Situated on the Thames River and an old Native American village contributed to wandering soul's manifestation stories on the grounds. The mass amount of area, connected by an intricate underground tunnel system used for access, utilities, and transporting patients to different wards. The tunnels were often an accusation of abuse where patients were said to have been chained and severely mistreated.

Norwich is one place I have only seen from the outside. Friends and I attempted to do night photography there and ended up on the other side of a SWAT team with a 9-mm in my face and these bellowing words across our nostrils, "Get on the ground, fuck face!" Being screamed at in friction was not what we had anticipated from the night. My answer of "I am not a fuck face, I am a girl" was not overly remarkable, but it worked to deescalate the situation. Sometimes, stupid is helpful.

Trust your gut. If you come from a military background and you tell your friends you see tactical movement with dogs in the trees ahead, and they say, "Probably just someone walking their dog," trust your gut. Suppose you hear a thud from the back of the building that is indeed your friend tackled to the ground by three officers; trust your gut. In reality, all you can do is steady yourself for the outcome.

The day we were on the grounds, we met nine officers and a massive Belgian Malinois police dog. Some long explanations and reasoning later—"Geez sir, back home we don't get met with aggression and arrested for walking and taking pictures of buildings"—the officers let us go with a ticket and told us to "hurry up and get your shot and don't come back here." Eventually, Officer Teenie dropped the trespassing tickets, and the photos were used for art shows and lectures to remember the asylum. To further prove that we all are not criminals, another one of us would later write a book on Norwich, giving lectures and seminars on its past.

Norwich's property has been tossed back and forth for purchase. Movie studios, entertainment complexes, amusement parks, and luxury resorts have all not happened. Norwich's Preston side, razed despite its historic architecture, has only a few buildings remain. The Mohegan Tribe has shown interest in purchasing the property and extending its current ventures. Word on the wind is that four times a year, Chief "Many Hearts" Malerba will come to light a cleansing fire until breaking ground for their plans. The fire's cleansing means purging the negativity while cleansing the land of the many spirits that have spent years here. If there is any truth to the rumor about the hauntings from the Stribling and Dix violent ward buildings, these cleansings can only be a good thing.

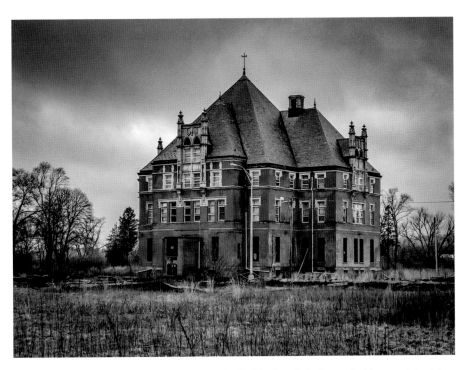

Norwich administration building in all its French Neo-Gothic glory sits hollow against the moody backdrop of the impending storm.

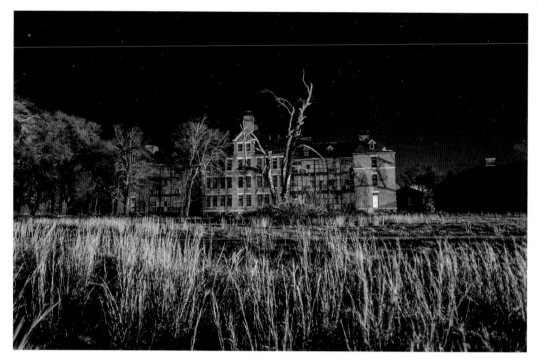

Here is a view across the fields of Brigham's late gothic revival architecture. Built in 1907, the wards housed male and female patients. Little did we know that it would become a distressing showdown with the Preston Police Department.

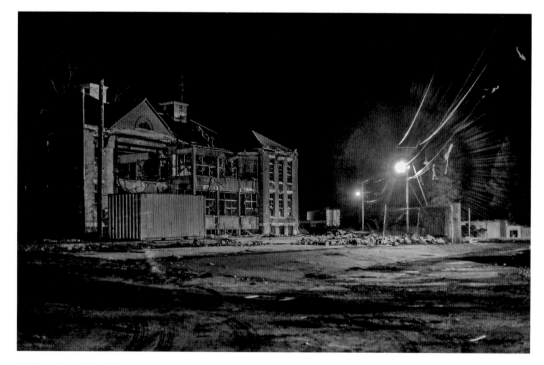

My first shot on film of Norwich's grounds walking in, getting the vibe of how I want to shoot. I would have never guessed that it was frowned upon to go hiking and taking pictures of buildings at night? I was definitely shown a different world early on.

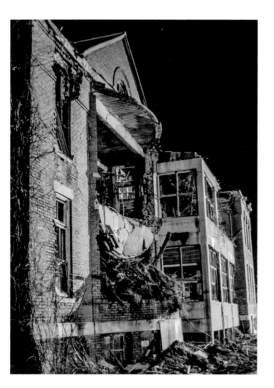 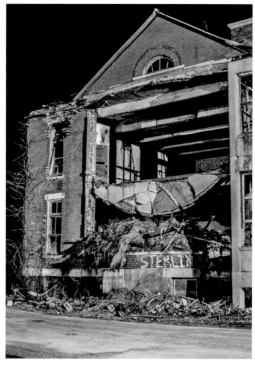

Above left: Sterling, as locals have named it, is actually officially named Stribling. It crumbles as if it is vomiting out the bramble from its mouth. Stribling, built in 1911, was the housing for violent male and female patients.

Above right: Stribling's façade was the first to crumble from the building, leaving a gaping hole into this Colonial Revival architecture.

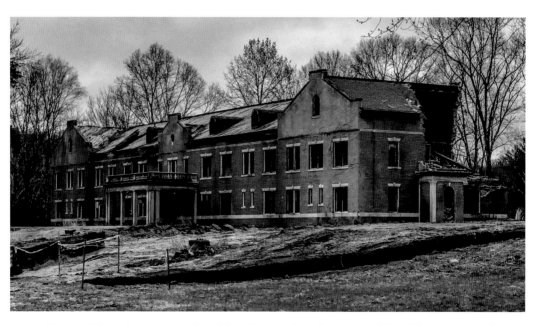

Darkness falls on the various empty buildings that remain on the grounds of Norwich, lending a somber and somewhat melancholy vibe.

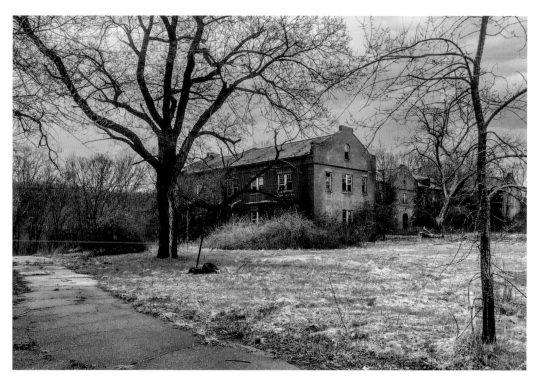

It is as if the tree is delicately reaching into the building's window, waiting to drag someone or something out.

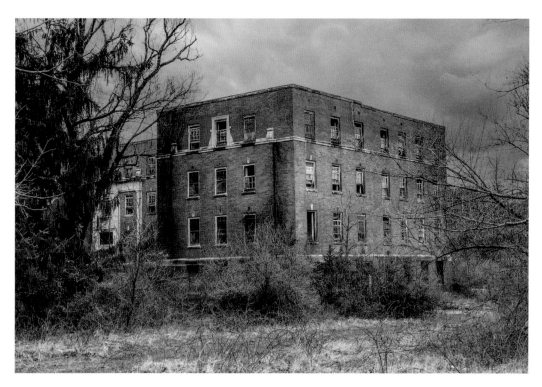

Though missing a roof, this building almost gives a Neo-Classical vibe with its mix of Greek and Roman cornices and pilasters.

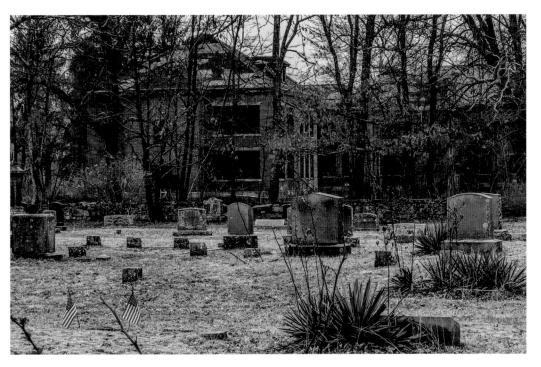

Brewster's Neck Cemetery is located on the Norwich State Hospital for the Insane in Preston. It is adjacent to the Brothers of Joseph Cemetery, and people will still frequent here to pay tribute with flags to fallen heroes or just visit their loved ones.

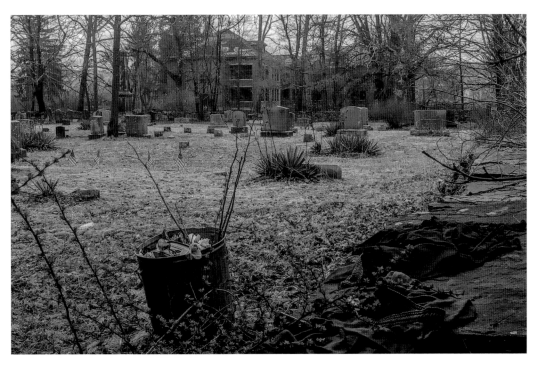

Norwich connects to the graveyard in Preston, leaving easy access for the homeless to seek shelter at night. Here, someone has left their clothes to wash (or dry) in the yucca-filled boneyard.

4

SEASIDE SANATORIUM, WATERFORD

"THE OCEAN ROLLS US AWAY"

Seaside, situated in the most alluring location known for a Connecticut Asylum, is a sight to behold. The water here is often so clear—blue, turquoise, and aqua—that you are mesmerized by the waves' ebb and flow for hours. Peaceful is the appropriate word despite being overshadowed by the looming yet enchanting Tudor Revival-style architecture of the children's tuberculosis hospital of the 1930s.

The building itself, artfully designed by Cass Gilbert, a renowned architect for facilities such as the skyscraping Woolworth Building or the United States Supreme Court Building, among many others, is remarkable.

The 36-acre property's structures were built initially to house the overflow of patients undergoing heliotropic treatment in a nearby Niantic Hotel. Heliotropic treatment is the extensive use of sun and clean air to treat tuberculosis. Gilbert would build sprawling verandas around the structure for the children to be in the sun and play.

New treatments for T.B. by medication soon came into play, and the site became stagnant. The closure was brief, being that in 1958 new residents with mental health issues inhabited the reimagined Seaside Regional Center for the Mentally Retarded. In 1961, Seaside had also been home for the geriatric community and eventually closed for good in 1996, remaining vacant.

Today, Seaside still sits picturesquely on the shore, and its grounds designated a state park. Huge barbed-wire fences encircle the remaining buildings like a tidy prison to keep would-be trespassers, graffiti artists, and paranormal groups out. The developer's ideas of its shell turning into hotels and its beach becoming a destination for sunbathing have yet come to fruition. She stands patiently against the rolling tides as a beacon of peace and tranquility while families play on her shores.

February 2021 brings uncertainty for Seaside as a senate bill brought forward questions about whether to dispose of the sanatorium's facilities.

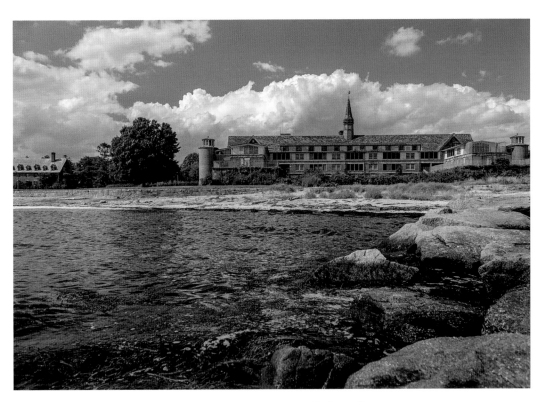

This is a view from the rock seawall of the picturesque Seaside Sanatorium.

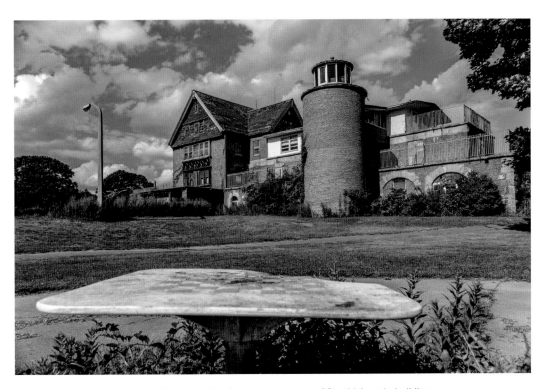

A weathered chess table tilts toward the Romanesque tower of Seaside's main building.

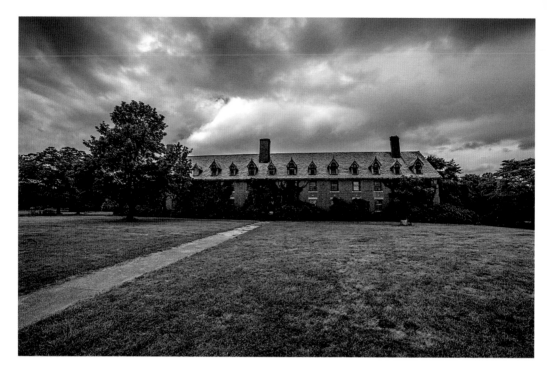

The ivy-covered face of Seaside's nurses' quarters and staff dormitory looks onward toward the sound. The building itself, by looks alone, has a sad voice. However, the nurses' rooms' insides were painted lovingly with bright pastels of pinks, purples, and yellows.

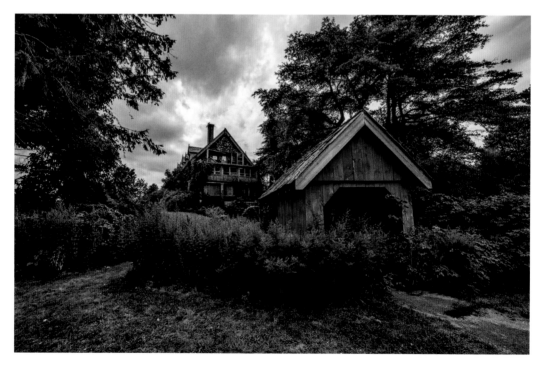

A small, red-covered bridge joins the two main structures of Seaside. The bridge adds a little nudge of quaintness that hopefully brought a pleasing aesthetic to the people looking out of the windows having to see it.

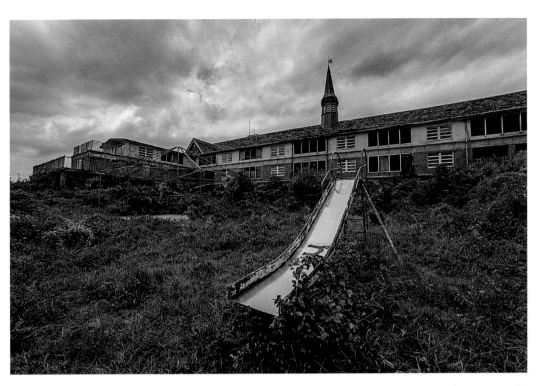

Seaside's spire looms over a long-forgotten, rust-adorned slide from the children's playground, overgrown with interweaving ocean rose and scrag as if trying to pull it into the ground with all the other buried memories.

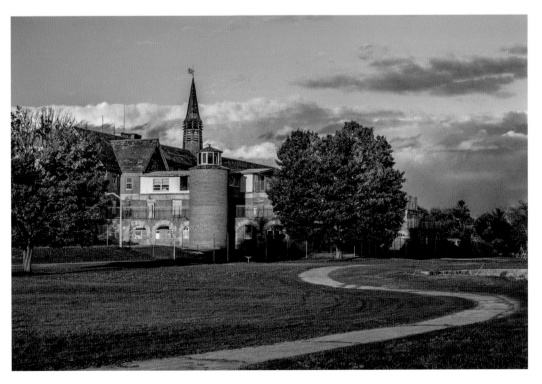

The state put a 6-foot razor wire fence around Seaside's main structure.

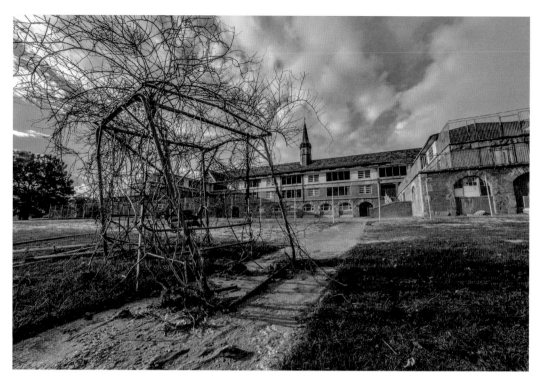

A bittersweet bound swing set seemingly becomes a raw, organic sculpture of its own as its vines reach upwards to the sky.

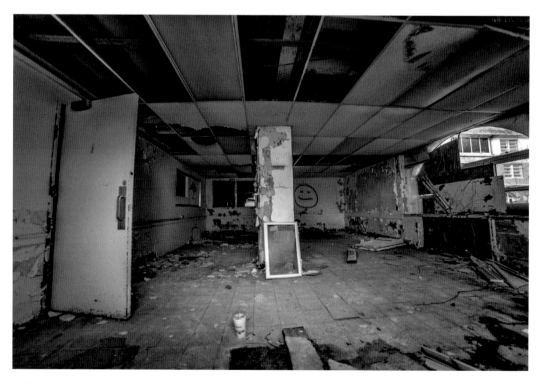

Mold, moss, and peeling paint—that is what abandoned buildings are made of.

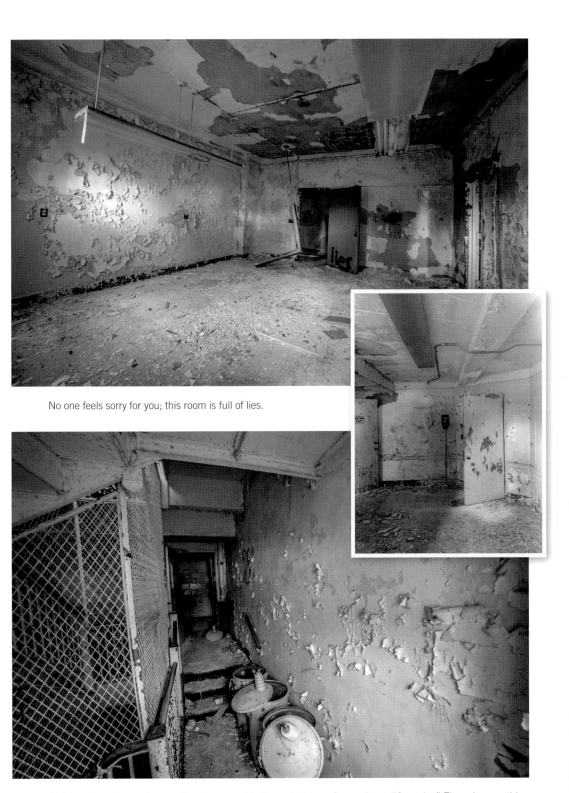

No one feels sorry for you; this room is full of lies.

Defunct electric transformers line the caged hallways between floors. *Inset:* "Crunchy." There is something very artistic about different colors, all scrambled together between the layers of peeling paint. I always find an appreciation for the textures and colors in decay. A stark white peeling room has a very modern vibe as well.

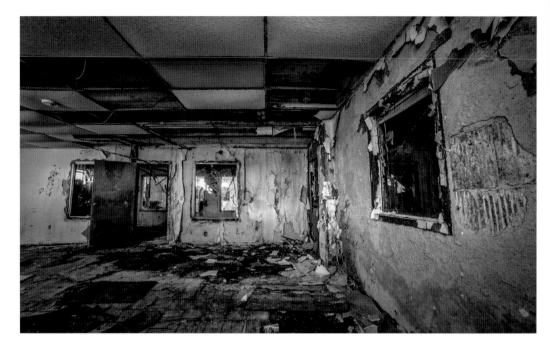

Yet more asbestos and mold running the floors' length, giving it a mossy forest floor texture. The furry growth creeps up the doors as the stucco fragments reveal the brick masonry's underbody. Smashed-out viewing windows seem to have an eerie semblance as if to tell you to stop looking.

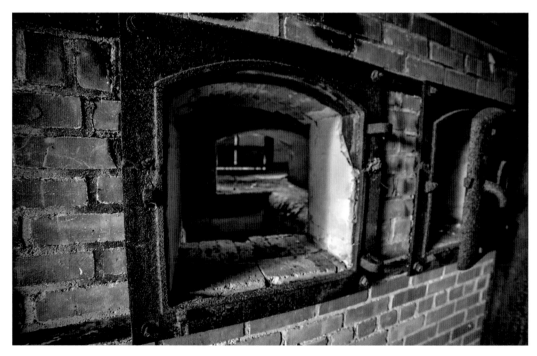

A depth of field shot toward the insides of the incinerator, pump house, and crematorium. The small, remote building that lies in a ragweed garden is what was once rumored to be Seaside's crematorium. Neighbors and internet trolls love to debate the ignorance of calling it a crematorium and instead swear that it was a pump house only; government maps and surveys also suggest this.

5

HOLYLAND USA, WATERBURY

"Jesus Wept"

Holyland USA is very possibly the most obvious, actively decaying landmark in Connecticut. Rising high above the town with its illuminated runway blue cross, Holyland becomes a beacon to any passers-by. Perhaps, this is why it has met with so much bad luck from vandalism to murder.

The religious tribute, erected in 1955 by John Baptist Greco and the Companions of Christ, Holyland is located atop Pine Hill, occupying 18 acres and boasting signage reminiscent of Hollywood's mountainside hovers desperately over the town of Meriden. The grounds originally consisted of a chapel, a small Israelite village, Bethlehem, an interpretation of the Garden of Eden, a diorama of Daniel in the lions' den, Stations of the Cross, catacombs, and some even depicting the ministry of Jesus. All structures, except for the cross and Holyland sign, were constructed from reclaimed items such as wood, stucco, chicken wire, scrap metal, and cinder blocks.

Regular wear and tear frequently beat the structures, and Holyland replaced the original 56-foot steel cross with a new neon cross and then again with a 65-foot, color-changing LED steel version. The color change's purpose is to coincide with the Catholic Liturgical Calendar and sometimes lends exceptions to autism and breast cancer awareness. Many masses and religious events called the site home, while noting that in ten years of the sixties and seventies, it was receiving 40,000 plus visitors a year. Again, due to wear and tear, Mr. Greco had closed the attraction down for repairs, and sadly, this is how it stayed due to Greco's death in 1986. Holyland then became the charge of the Sisters of St. Lucy Filippini, who reside on-site behind tightly closed doors. The Sisters, not charged with the reconstruction, were leaving it to the board of directors. The property would see another transfer of hands to the current owner, who has had high renovation hopes. However, the Sisters and property owner soon saw their precious Holyland disappear as a victim of scrub elements, people, and eventually murder.

April 2010 gruesomely marked the religious grounds forever when sixteen-year-old Chloe Ottman was raped and murdered by her boyfriend's best friend, Francisco Cruz, underneath the giant icon of hope. Chloe was found strangled, stabbed in the neck, and her body and her belongings were found where he left her thrown in the woods. Chillingly, the pair had just walked Francisco's mother home. Cruz, who was nineteen at the time, told the court he was angry that Chloe never gave him a chance, and when she elbowed him to the face and knocked off his glasses, he found himself drunk and enraged. He started choking Chloe until she passed out. As Chloe regained consciousness, Cruz decided to kill her, strangling her again and stabbing her multiple times in the neck to make sure she was dead. Cruz said he was afraid of the time he would do in prison for the rape. Ensuring she was lifeless, Cruz then raped her again and discarded her in the remote woods beneath the Holyland sign. Even though Cruz could have gotten the death penalty, he pleaded guilty and was only sentenced to fifty-five years in prison for stealing an innocent, vibrant life.

Over the years, various vandals and self-proclaimed graffiti artists have left offensive messages and swastikas throughout the site, leading to significant setbacks in the ongoing revitalization project. However, they have not given up hope at Holyland as recently as December 31, 2020, their show of endurance bled through with a fireworks display for the 2021 New Year.

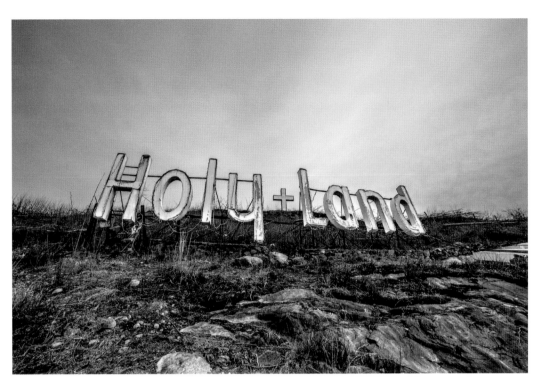

Holyland on the hill over Waterbury, CT, mimicking the Hollywood sign.

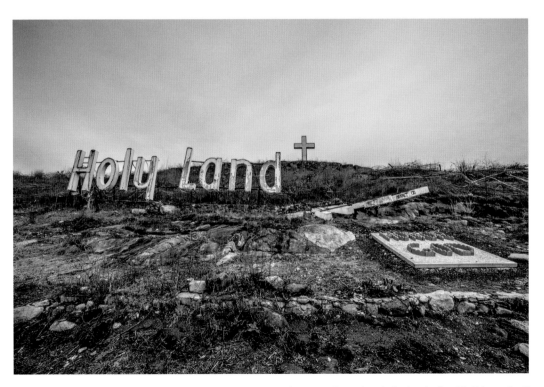

Vandals have "tagged" and detached the USA part of the sign from the whole, ironically with "Honor God" stationed right beside it.

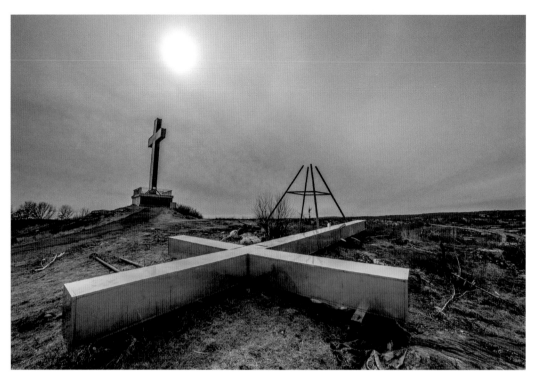

The prior cross lays discarded beneath the staggering and monstrous new cross.

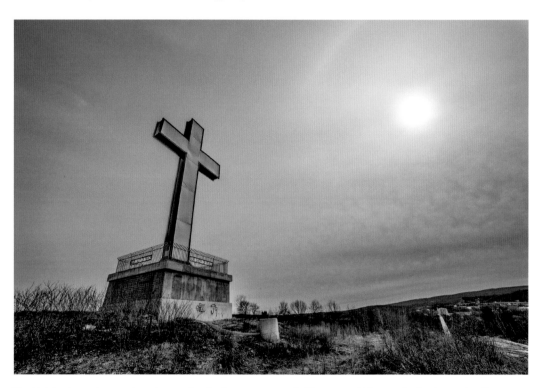

The Holyland cross's newest version reaches for the sun surrounded by a wrought iron protective fence atop its brick and concrete pedestal.

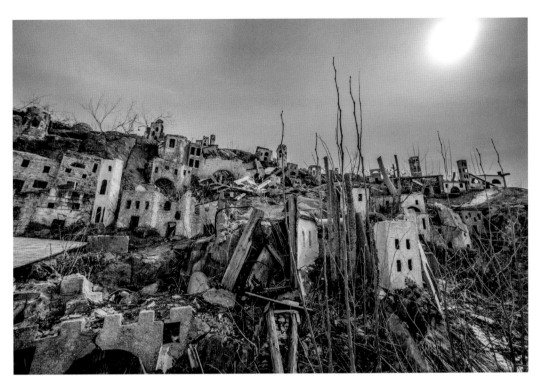

Holyland's holy villages of Jerusalem and Bethlehem constructed of chicken wire, plaster, concrete, and scrap metal sit among the scrub waiting for revival.

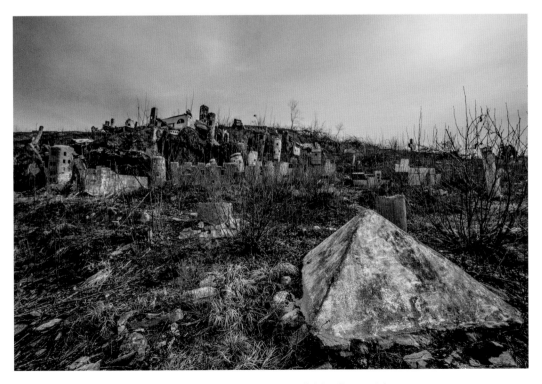

Yet another view of the decrepit villages laying waste atop Holyland's mountain.

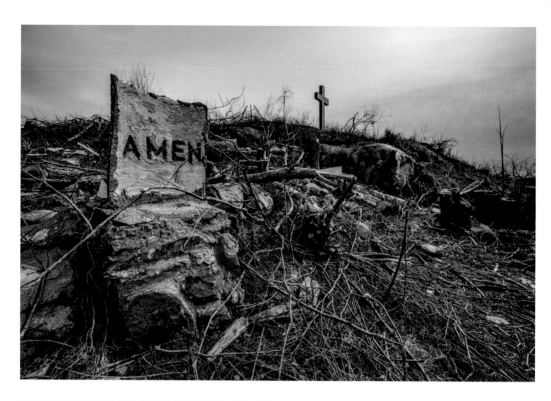

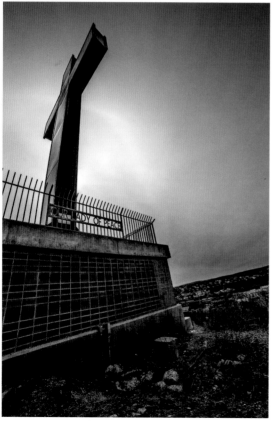

Above: The material with staying power that has weathered the elements seemed to have a sort of visual cue. "Amen."

Left: Our Lady of Peace forged into the ironwork around the cross where Chloe Ottman lost her life. I cannot help but wonder how the nuns that lived on the property did not hear her screams?

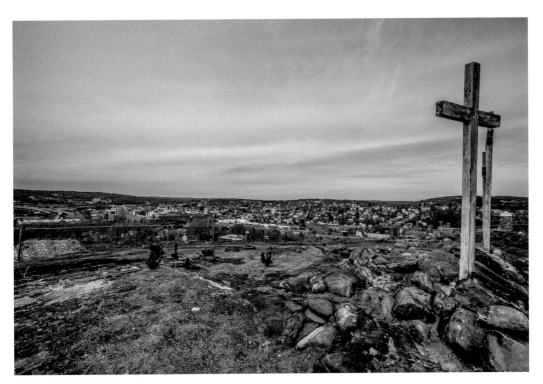

The worn wooden trinity crosses languish on the hill overlooking Waterbury, reconciling the sins of man with god.

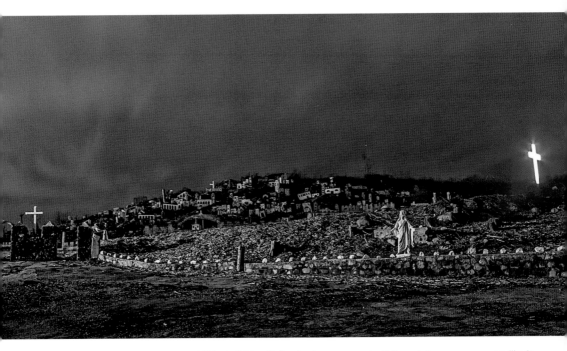

The panoramic view of Holyland USA at night, with its glowing cross and religious statuary, seems more like it should be a place of peace than a sad reminder.

6

CHROMIUM WAREHOUSE, SHELTON

"ALL OF THESE MOMENTS ARE LOST IN TIME"

The earliest record of the building for Chromium Process Company was 1898. The Chromium Process Co. business was established in 1927. The plant made almost anything that used metal-finishing from medical supplies to car parts in nickel, copper, and chrome finishes. Production stopped in 2009; families lost their jobs, and the Shelton landmark permanently shut down. By 2016, it was razed to produce a bright and not-so-shiny parking lot.

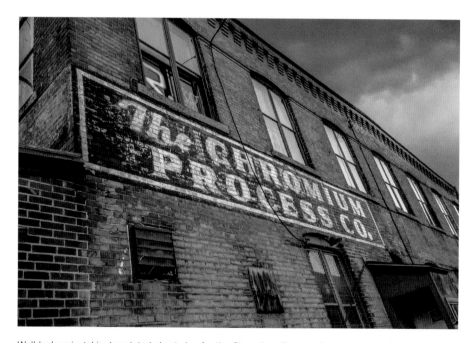

Walldog's painstakingly painted ghost sign for the Chromium Process Company's warehouse.

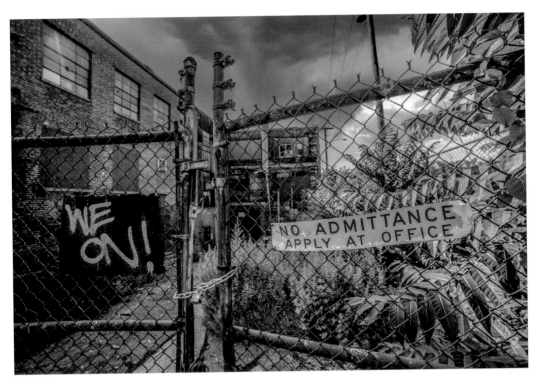

The locked non-admittance gate seemed to pose a challenge to some taggers.

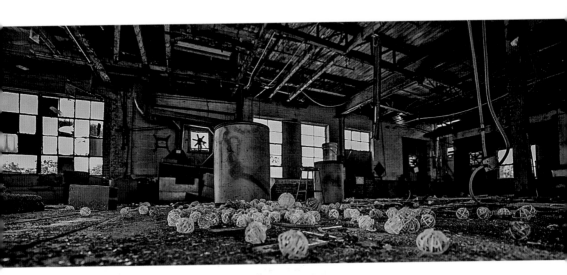

Plastic agitator balls tumble out of barrels and lay scattered across the oily floor of the chromium plant.

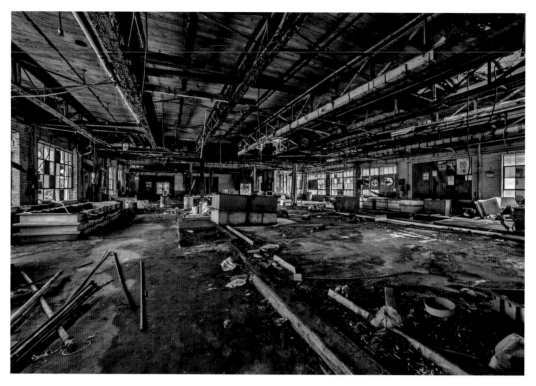

A lengthy shot of the chromium plant's first floor offers a good idea of the warehouse's girth and size.

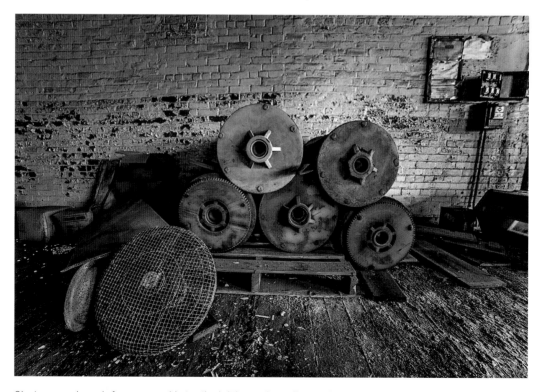

Giant cogs and spools form a pyramid atop the brittle wooden pallets against the back wall of the plant.

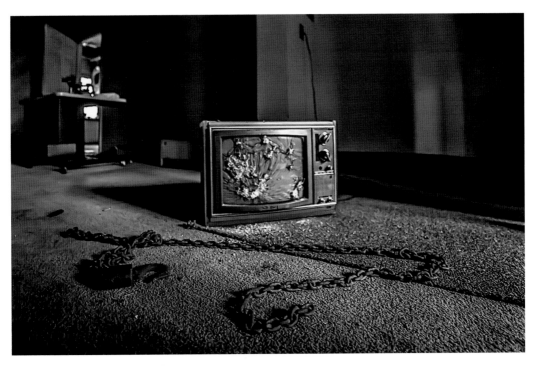

A lifting hook and chain were obviously an easy tool to destroy property at the warehouse. I will probably never understand the destruction of other people's things regardless of use or age. I mean, that TV would have made a fine upcycled fish tank.

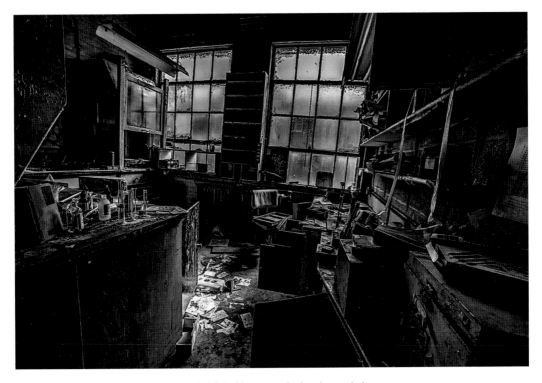

The Chromium Process Company's lab looking ransacked and corroded.

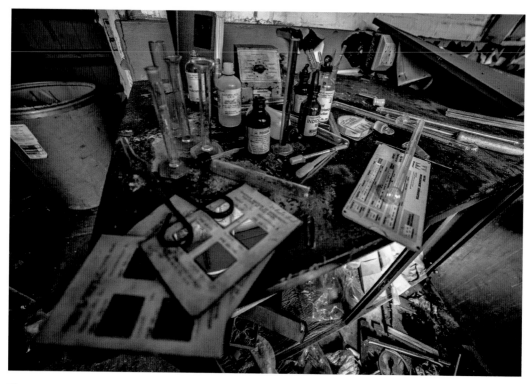

These were the tools used for testing chromium.

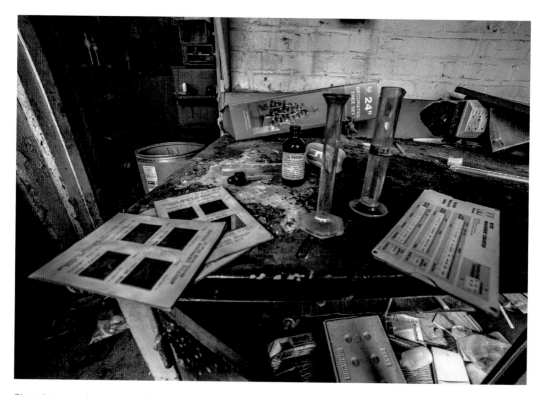

Chromium swatches are used for consistency, color, and also breaking down the formula for use.

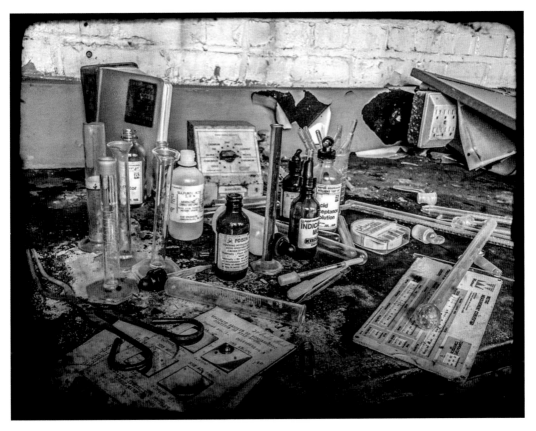

Atomic and the most rigid element, behind carbon and boron, many poisons and acids have to be used to test chromium. Hydrochloric acid was still sitting on the table as if waiting to be used tomorrow at work.

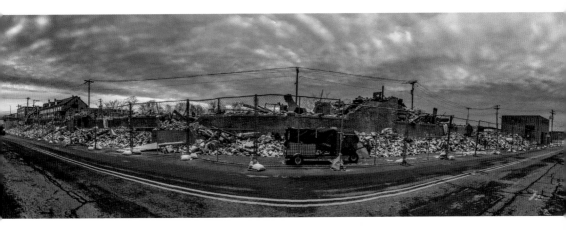

The demolition of the Chromium Process Center made way for a parking lot in Derby.

7

STAR PIN FACTORY, SHELTON

"SO MANY VOICES AND NOTHING IS THERE"

In 1874, Star Pin Factory was a thriving industry contributor to Shelton's manufacturing town. They were the primary producers of pins, hairpins, and garment eye hooks. Despite great success, developing an automated hairpin making machine, having the first machine to produce bobby pins, and eventually adding folding box making to the product list, the demand over time waned. Star Pin closed its doors in 1977. In place of 145 years of what once stood are now leveled ruins due to a fire in June 2020. The massive blaze engulfed Star Pin and a neighboring building. The fire took 150 firefighters three to four hours to take down. Sadly, Star Pin is just another recent victim of arson in many Connecticut abandoned complexes.

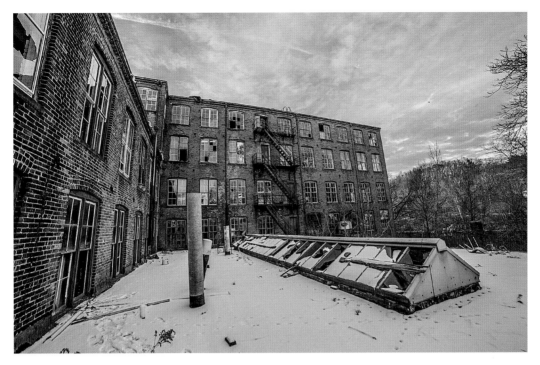

Despite the permission given to explorers and artists, we were asked to enter through the building's back. This type of entry was due to how construction was taking place, and the building was sealed. Here, you see where we had to scale a 6-foot wall in the snow and enter through a broken window on the second floor.

These were the outbuildings and the walk to access Star Pin.

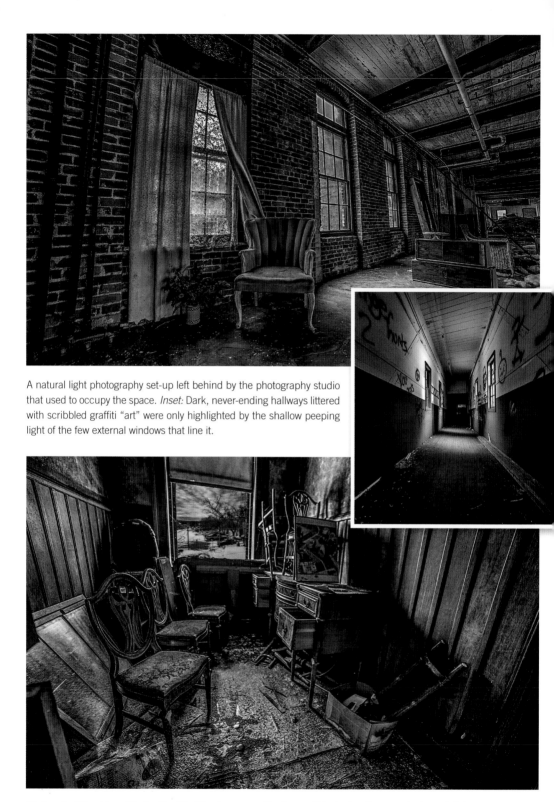

A natural light photography set-up left behind by the photography studio that used to occupy the space. *Inset:* Dark, never-ending hallways littered with scribbled graffiti "art" were only highlighted by the shallow peeping light of the few external windows that line it.

My favorite thing I found in the Star Pin Warehouse was the few undisturbed antiques, a desk, and dining room chairs. An Escher sits on the desk as if waiting to be hung in the office lined with remarkably masculine wood panels.

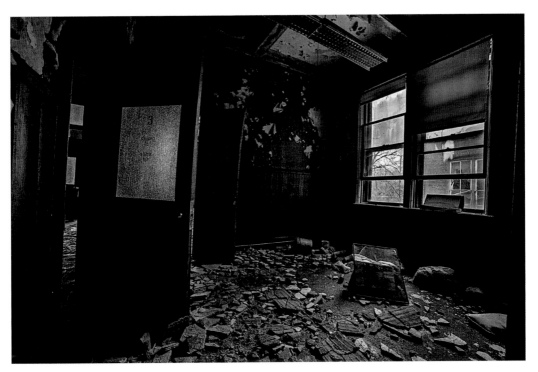

Studio C, Suite 517, gives a staggeringly investigative vibe. Here you would come to the smoke-filled room with your noir lighting peeping through the blinds from the streetlight below and tell your private dick the story of your missing husband as he ogles you from underneath his grey fedora.

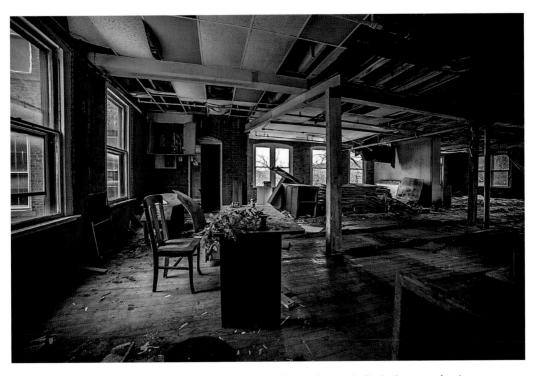

Moss covers parts of the original wood floors while mildewed sheetrock piles in the corner for cleanup.

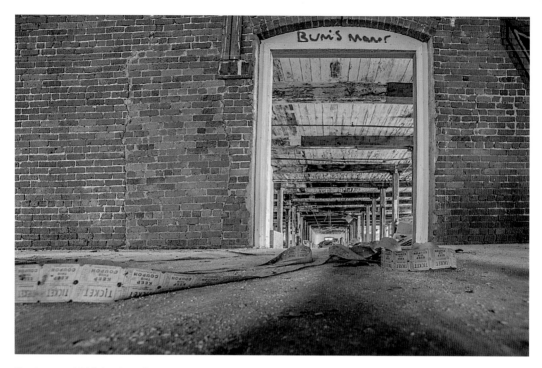

Bum's manor highlights the soft archway where someone lost all their carnival prize tickets. I cannot believe they would not want to go back to get an 8-foot puce dinosaur.

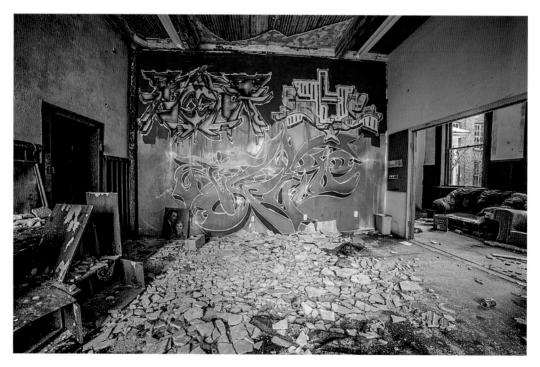

An artist's lounge. Couches and milk crates line the windowed walls of this floor for thinking of the next masterpiece these taggers might come up with. By the looks of the tossed paint cans and rubble of the walls, this was a break-out artist.

8

SOUTHBURY TRAINING SCHOOL, SOUTHBURY

"Folded and Yellow and Torn at the Edge"

Southbury Training School, built in the 1930s to house adults with intellectual disabilities, had its first patients admitted in 1940 under the title "School for Mental Defectives." In 1948, there were also documented photographs of Southbury having a T.B. unit. The campus is 1,600 acres of Edwin A. Salmon's Colonial Revival architecture. S.T.S. has housed upwards of 2,300 patients and was an example of an independently run institution creating its heat and power, water, and sewage systems. S.T.S. even had an ambulance, fire station, and public safety officers. The school remains reputed throughout its history as one of the best centers for this type of impairment. In 1959 Southbury was transferred to the Department of Health, Office of Mental Retardation.

The 1970s pushed to do away with mental facilities. In 1975, the training school was transferred to a new department of "Mental Retardation." Lawsuits ensued, claiming substandard and dangerous conditions, and in the 1980s, S.T.S. brought in a no new admittance rule. The residents would live out their remaining years; after the last patient is gone, they would then address what to do with the school.

The 1980s onward saw S.T.S. placed on the National Registrar of Historic Buildings and is still partially active. In 1987, Dustin Hoffman and Tom Cruise very sensitively visited to prepare for their roles as a severely mentally handicapped man and his brother for the Levinson movie, *Rain Man*. In 1997, five urns of remains were found of former residents in two local funeral homes without a final resting place, further fueling hearsay of the Ella Fleck Building's hauntings. Several actions of unconstitutional conditions have arisen since.

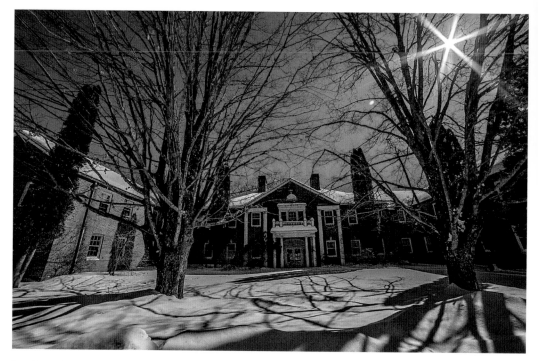

Southbury Training Schools' more pristine buildings were located towards the front of the property, often used for storage. These would be the first front-facing structures that one might see passing by.

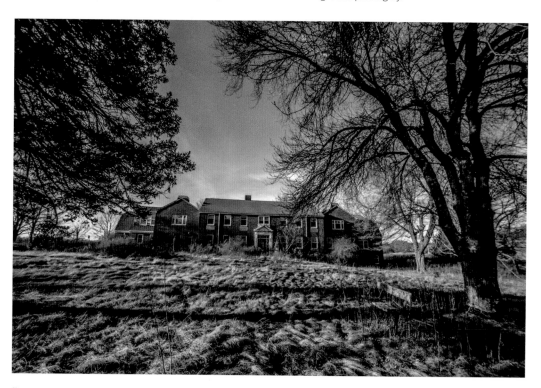

Extensive land is a charming characteristic of this facility compared to others. Patients had plenty of room to be outside.

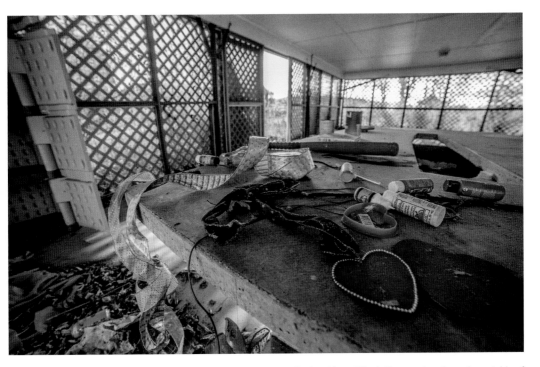

Christmas craft ribbon and paints still occupy the stone picnic tables of the lattice-enclosed gazebo outside of one of the school's training portions.

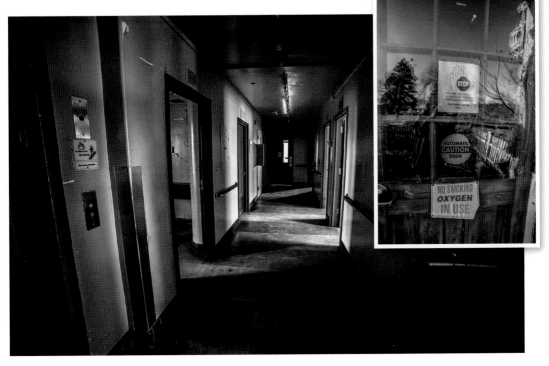

Flesh pink-colored hallways, bringing to mind many 1970s bathrooms, look clean and show little wear.
Inset: Due to contagious disease signs, restricted access still warns visitors on entrance windows throughout the T.B. and infectious disease ward.

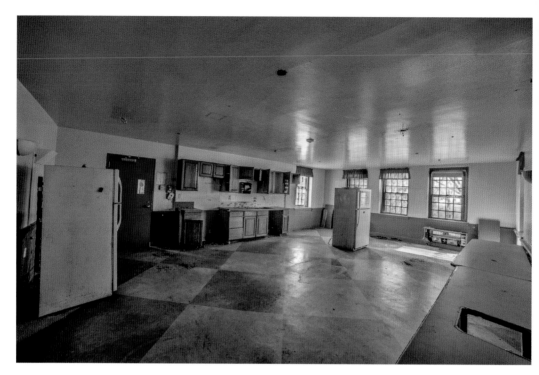

The kitchen—sprawling with its circus-like red and white checkerboard tile floor, Christmas-colored valances, and '80s cabinetry—looks like it could feed an army.

I have a feeling that the hallway painter was either an E.C.U. alumnus or from Louisiana. Bright yellow cinderblocks were sure to make the S.T.S. a happy place.

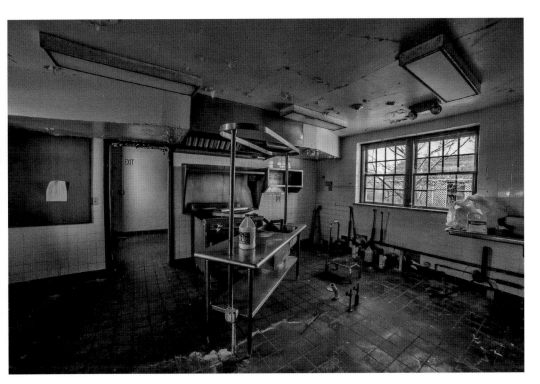

The cooking area of the training center looks like it was left mid-clean.

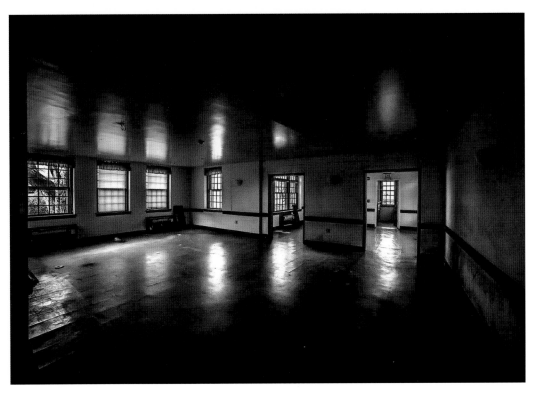

This would be one of the common areas of S.T.S. off the E.C.U. hallway.

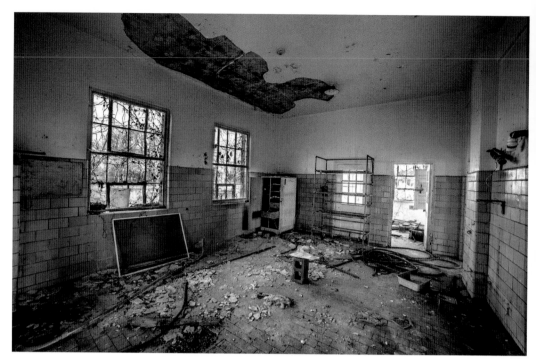

The dingy, fleshy, and yellowing subway tiled walls of the electrical building show little indication of what may have happened daily. Hoses, plastic barrels, and conduit piping are pretty much all that is left.

Many years have been spent at the Southbury Training School farm area for birding, sunsets, abandoned night, and wildlife photography.

In minutes, the colors change as well, leading to endless sunset opportunities. New farm businesses, like Daffodil Hill Growers, have popped up to lend color to the landscape as well; it is just minutes down the road.

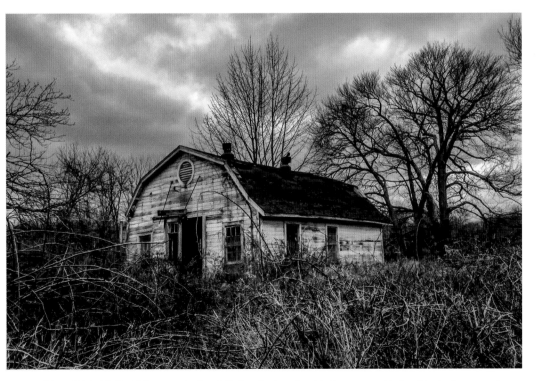

It is unthinkable that this was actually a fully functioning slaughterhouse, considering it looks the same size as our sheds at home.

9

MANSFIELD TRAINING SCHOOL, MANSFIELD

"LIVING MAKES ME FEEL ASHAMED"

Mansfield Training School originated in 1860 as the Connecticut School for Imbeciles in Lakeville, Connecticut, to treat the mentally handicapped. The Greek revival and late Victorian architecture built in 1917 resides on 350 acres. The building came just after the institution changed its name yet again, two years earlier, to Connecticut Training School for the Feebleminded at Lakeville. The construction followed a merger with about 400 patients from the Connecticut Colony for Epileptics.

A surge in patients from the 1930s–1960s made housing patients hard, putting most on waiting lists. Again, the 1970s showed a decline; accusations of poor conditions and abuse lead to its closure in 1993. The available buildings were split up between the University of Connecticut, Ballard's Institute of Puppetry, and Bergin Correctional Facility. Buildings became demolished, which stopped when the National Register of Historic Places added the school in 1987.

Most institutions that housed these types of mental illness were subject to scrutiny. Times change, and what we find offensive or unsettling now was usual in past years. Medical classes were taught where, uncomfortable as it may have seemed, doctors brought the patients on stage, and their abnormalities were pointed out to the medical students to study. Individuals with ailments that fell under terms such as mental retardation, epilepsy, congenital disabilities, Down syndrome, and dwarfism, as well as unwed mothers became committed there as well. Padded walls, chains, straitjackets, and sheets are all talk—are they real or have they been brought in by people trying to fake a creepy atmosphere?—in addition to explorer-found viewing rooms with open bath facilities, with the door handles affixed only outside.

Paranormal groups and the television series *Paranormal Witness* made Mansfield a consistent go-to, stating incidents of frequent sightings, orbs, shadow figures, and hallway whispers. Two activity hotspots are Knight Hospital and the Mansfield Mansion.

The mansion, built in 1870, had initially been the home of the superintendent of Mansfield's epileptic colony, later becoming the site's administration office. Tunnels connect the farmhouse to the campus. Patients were said to have been kept in nothing but adult diapers, tied to chairs, and had the higher graded patients ordered to "get them." Hauntings and human remains of a murdered little girl were famed found in the basement. Investigations have not found evidence of these allegations.

A double rainbow appears in the distance over Mansfield Training School as we approach the campus.

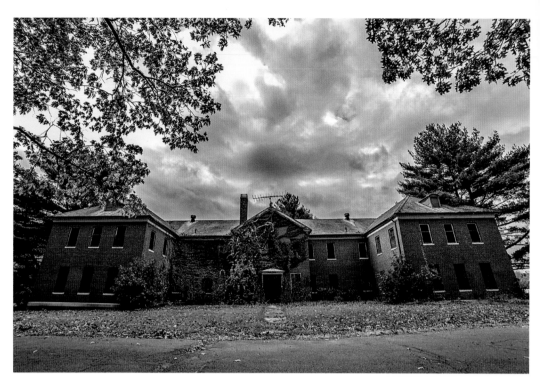

Lurking ahead is Depot A, looking somewhat ominous under the angry sky.

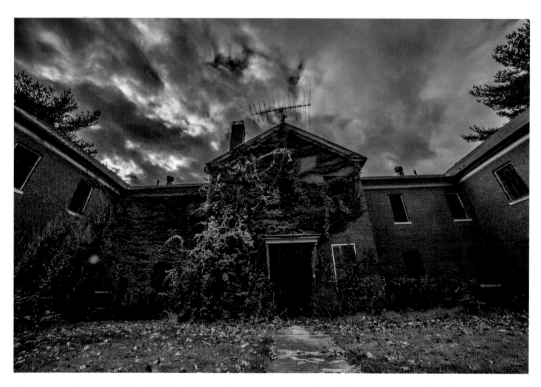

Boston ivy ambles across Depot A's front in a phalangeal manner as if windblown, yet seemingly to clench the building in its possession.

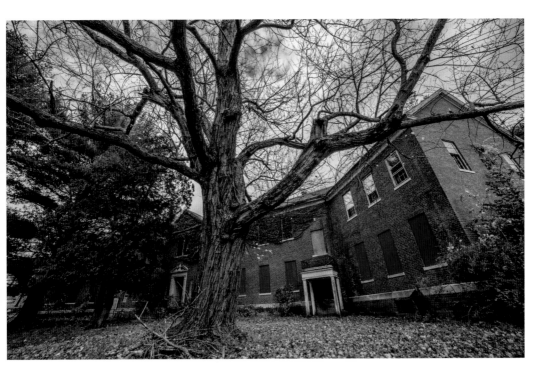

Depot B is secured for revival for the UCONN campus, yet access seems to be obtainable as the basement grate is ripped off.

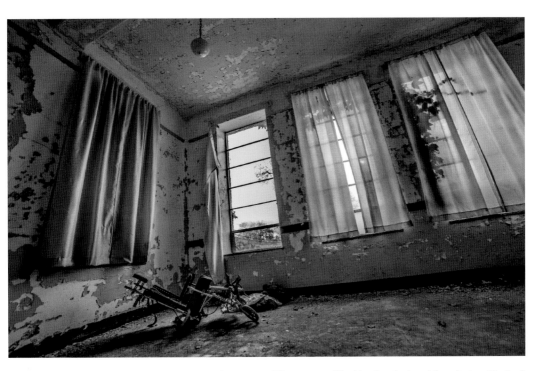

An early broken pediatric chair rests in the corner of the room as if looking longingly out the window. Maybe it is the same position it was left in from the last onlooker. The faded curtains give some indication of how long it has been sitting in wait.

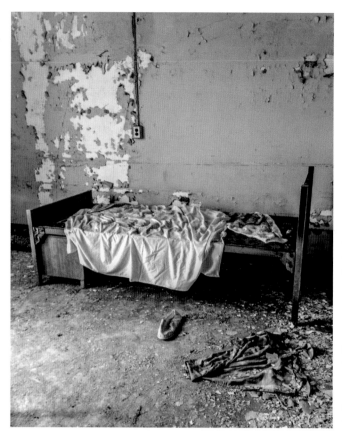

Left: A slipper, one faded green frock with purple silk bows, the flat sheltering sheet, and a dirty towel envelop a very institutional bed. Perhaps, the occupant leaned into the wall, head pressed upward, methodically picking the paint from their enclosure's wall and then tossing them carelessly to the floor below.

Below: The equipment was thought to be used for sound wave treatment therapy.

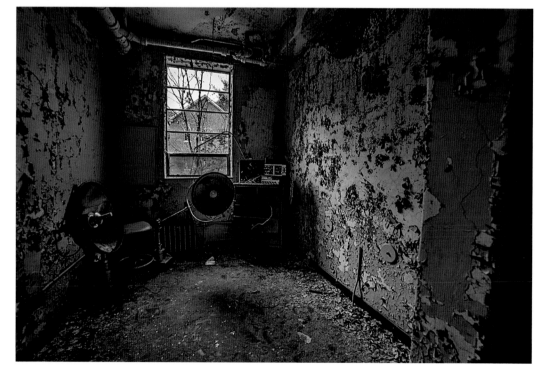

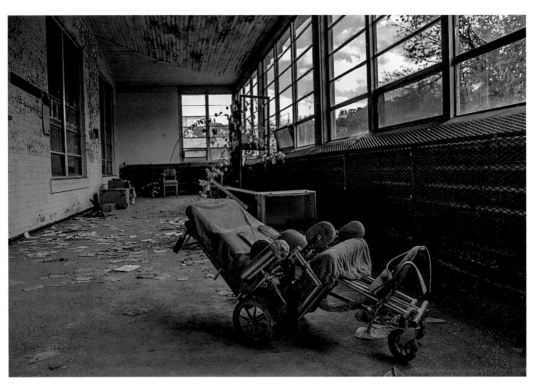

A tilting wheeled chair with restraints for transferring paraplegic or violent patients lingers in the hallway facing the louvered jealousy windows looking outward to the fall foliage.

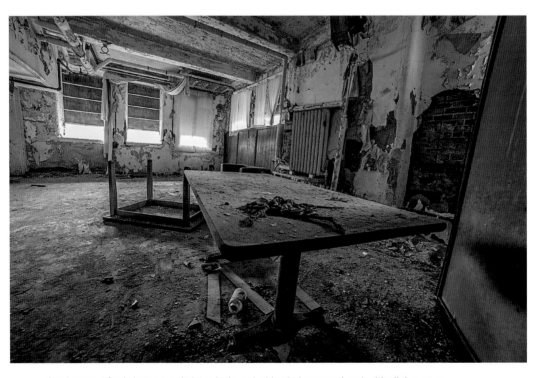

An almost perfectly intact cat skeleton is the only thing being served up in this dining room.

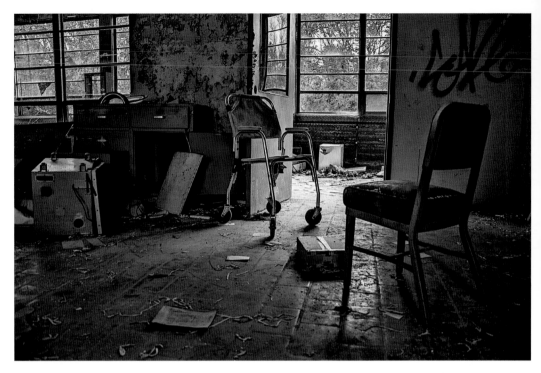

Toppled autoclaves and a canvas-backed toilet chair with restraints set the theme here. Bedpans for the chair and metal bowls from dental equipment sit in a sink waiting to be sterilized.

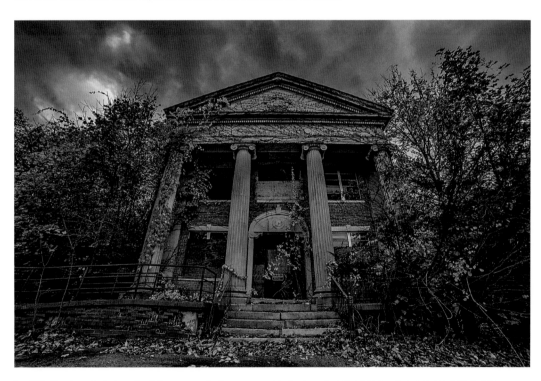

In all its Greek revival glory, the infamous and often rumored to be haunted Knight Hospital remains a go-to for the paranormal community for investigations.

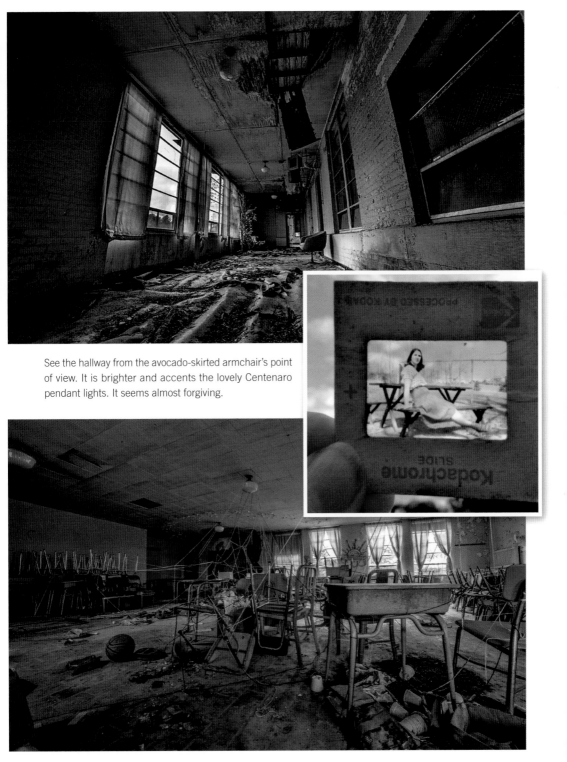

See the hallway from the avocado-skirted armchair's point of view. It is brighter and accents the lovely Centenaro pendant lights. It seems almost forgiving.

Student desks tangled like prey in this web of yarn. The toy room was across the hall as some of the balls found their way into the classroom. *Inset:* A Kodak Kodachrome slide was found on the floor of our last stop. Was the lady in the blue skirt and orange gingham shirt a resident? Could she have been one of the staff? I guess we will never know.

10

CASTLE HILL MANSION, NEWTOWN

"ALL OF THE LIVES THAT I'VE NEVER LIVED"

Tucked high on a hill, behind a magnificent stone wall off Castle Hill and Jimmy Cake Lane, was a quiet 1908 mansion named justly Castle Hill; in addition to being named after its community, it was also named after the last castle overlooking Newtown's treetops, a house many felt was the crown of that specific area. The Roman Catholic Diocese of Bridgeport owned the stone and wood house, though people have eyed the property for years, from developers wanting to make the parcels into cluster multi-family living to the Newtown Forest Association for preservation. The Gretsch Estate conveyed the property to the Diocese in 1995. They had initially planned to use it as a retreat center, but instead, it had sat abandoned.

Castle Hill was a one-and-a-quarter story Cape Cod-style home with a moderately steep pitched gabled roof of concrete tiles. The mansion occupied 5,703 sq. feet per the Tax Assessor's database. The estate totaled seven bedrooms, formal dining, a grand staircase, walls adorned with the finest woods, encased windows to view the grounds, and all the fabulous nooks, crannies, and hidden doors that dream homes should have.

Dick Gretsch was the original owner of Castle Hill since 1954. The Gretsch name is known to music enthusiasts as a famous brand of instruments, namely guitar, mandolins, banjos, and drums. Richard Francis Gretsch and his bride, Barbara, lived happily at the Castle Hill home overlooking the town for more than twenty-six years. In the late 1980s, and after his wife's passing, the family sold it to the Diocese of Bridgeport in hopes that the house and land would be preserved and undeveloped. The last purchaser intended to honor this request by refurbishing the property as it was, but tragedy struck.

In May 2016, Castle Hill fell victim to the rampant savagery of arson like so many of our Connecticut abandoned landmarks. Initially, the thought was that lightning had taken the mansion, but it soon became apparent that arson was the culprit. The inferno required seven fire companies and 230,000 gallons of water to extinguish.

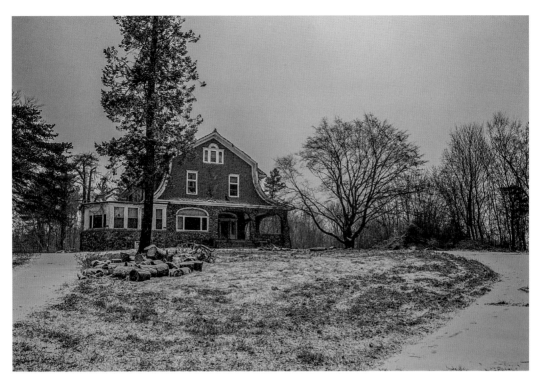

The winding walk to the exterior of the cape house that was known as Church Hill Mansion.

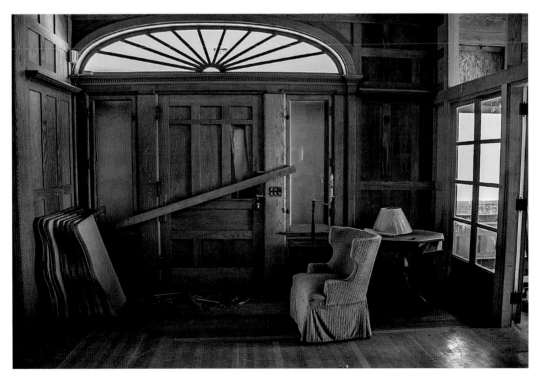

Four full head- and footboards, a corduroy armchair, peeling veneer ebony end table, and that 1980s lamp/table/ magazine rack that no one wanted all sit by the boarded-up front door as if waiting to move.

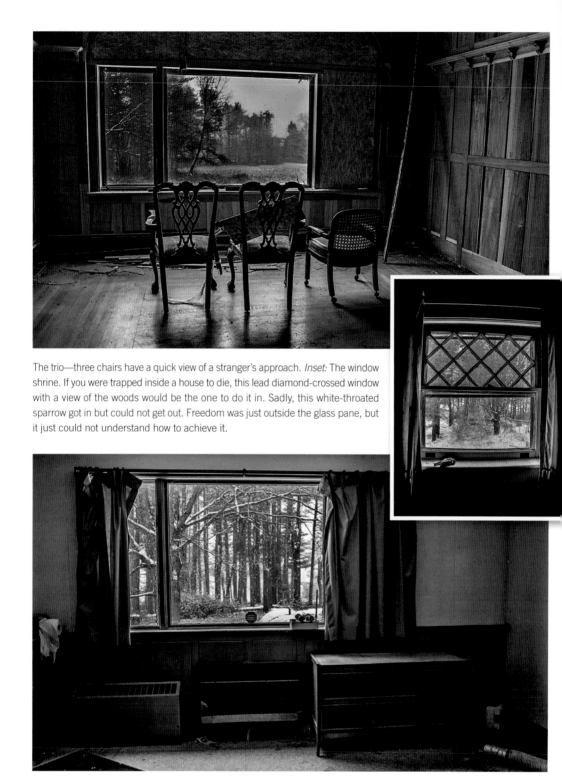

The trio—three chairs have a quick view of a stranger's approach. *Inset:* The window shrine. If you were trapped inside a house to die, this lead diamond-crossed window with a view of the woods would be the one to do it in. Sadly, this white-throated sparrow got in but could not get out. Freedom was just outside the glass pane, but it just could not understand how to achieve it.

The neglected Mid-Century Modern stereo cabinet and a pair of microphones border the eat-in kitchen. I love the old stereos, but I have left many behind (much as these people did) as they are heavy and hard to move. If they work, they are charming functional pieces. What is going on with the toilet paper, though?

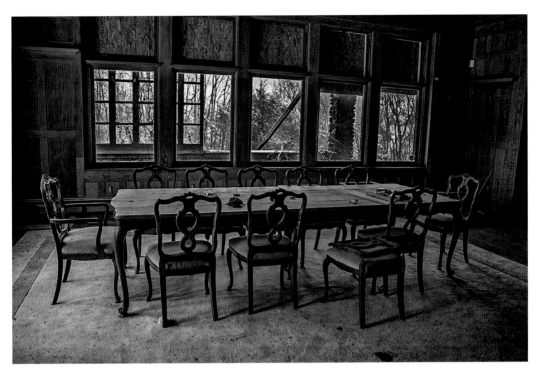

A ten-piece formal dining table set sits atop a majestic pastel blue and cream silk rug. The rug itself gives a very oval office vibe. Raised paneled woodwork continues its theme in this room as well. The many windows provide views of the stone porch and snow-covered forest from the table while having a meal.

You have to respect this flawless raised wooden beauty of a staircase from top to bottom.

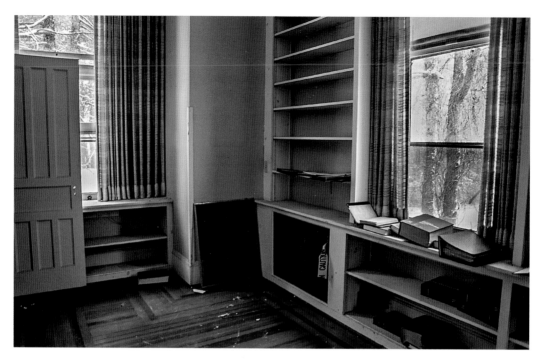

The study's bookshelves still have law books occupying them, strewn about like someone studying for a big case. Masculine ochre yellow dates the room in the '70s with the yellow and white woven, chunky slubbed hand curtains. The retro Danish curtains tie the room together for an authentic vintage look.

Cotswold Green walls give fair contrast to the burnt orange rug and warm-toned inlaid wood floor. The radiator and cornice assume the same color with white sheers and an ornate leaded glass window. A stool, sage and skirted, sits solitary near the window.

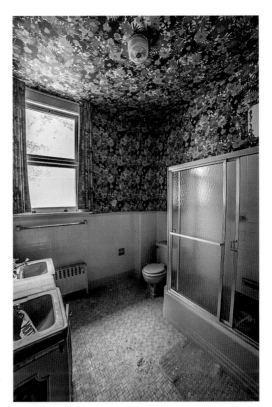

This '40s–50s style Pepto pink bathroom was probably all the rage for the girls in the house, all tied together with the '60s floral wallpaper showing. I cannot help but wonder what the paper was before it.

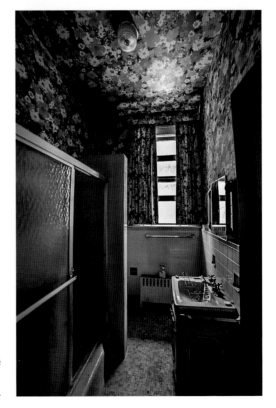

Seafoam tiles and pink sink and tub are just mere accents compared to the 1960s floral wallpaper and matching curtains that encase this bathroom.

Left: Natural light beams through open doors, giving a distortion to the angle of the bedroom doorways.

Below: A basement cabinet still houses the shoes and ice skates of the family that once lived here.

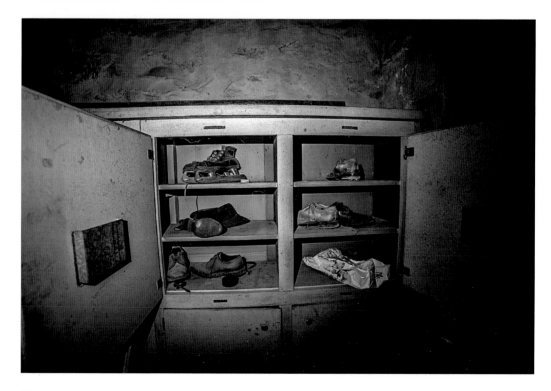

11

LION HILL FARM EQUESTRIAN CENTER, EASTON

"Caught in My Head Like a Thorn on a Vine"

Lion Hill Farm, located in Easton, Connecticut, was established in 1992. The property boasted large heated indoor and 103×225-foot sand outdoor arenas offering horse riding lessons for adults and children. When not engaging in competitions, other activities and trades included summer camps, birthday parties, boarding, and horse-leasing. Once, the thirty stalls at Lion Hill housed many horses from Arabians, Appaloosa, Morgan, and thoroughbreds. Gincy Self Bucklin trained most who visited. She was a co-owner, sixty-plus year riding teacher, and prolific author.

An 1889 Victorian farmhouse called Sweetbrier abuts the entrance to Lion Hill. "Sweetbrier" is adorned lovingly across the turret in a whimsical font. Litter and beaten appliances strewn across the lawn as they attempt repairs are highly unusual for the affluent Easton town. A nice gentleman said:

> The last renter had cats, lots of them, and I think the raccoons were sleeping inside too. Have you ever tried to get cat and raccoon pee smell out of hardwood floors? It's going to take much work, but it is worth it as it was once a beautiful home.

"No, sir", I said, "and I hope I never have to."

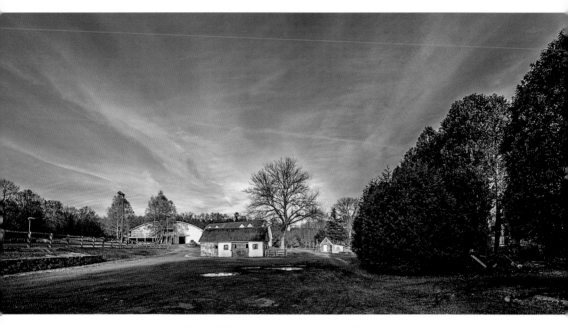

See a dramatic, panoramic look of Lion Hill Equestrian's grounds located in Easton.

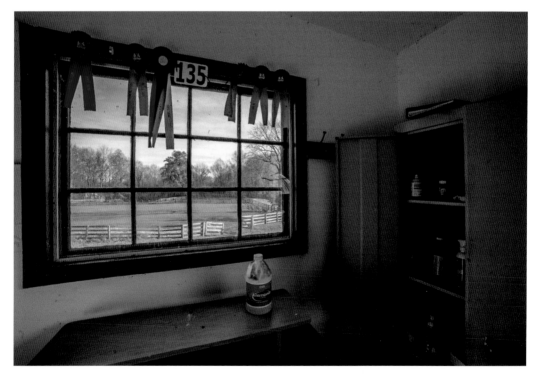

The picturesque window view of the outdoor arena is lined with winning ribbons like a valance.

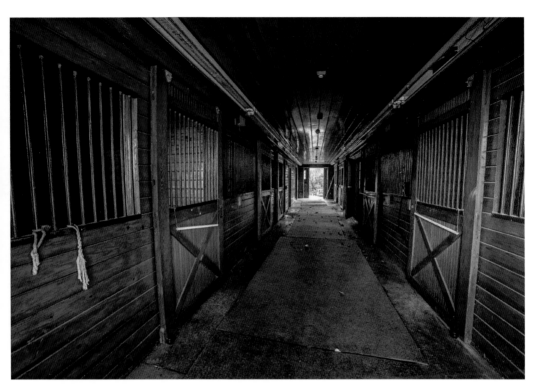
A dream stable would consist of rich mahogany wood, clean and left like the last day of use.

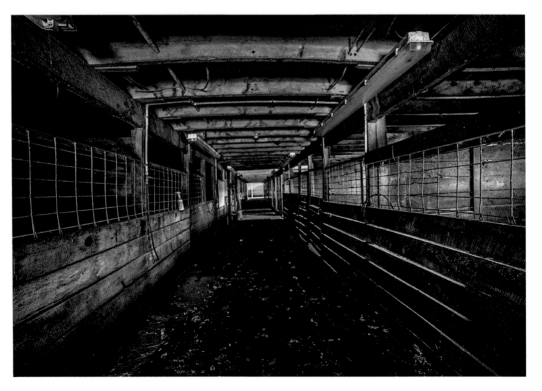
This shot allows a long hall perspective of the unused stables.

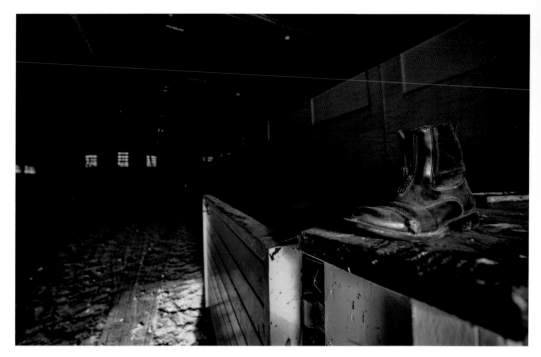

The mystery of the one shoe. How does one lose just one shoe? Here, I suppose, it could be understandable in light of the highway one-shoe mysteries. Perhaps a horse threw you out of your shoes. Does one not then retrieve their shoe eventually? We may never know answers to these questions. *Inset:* The last bath—a spent horse sponge occupies the window seal of the hazy window.

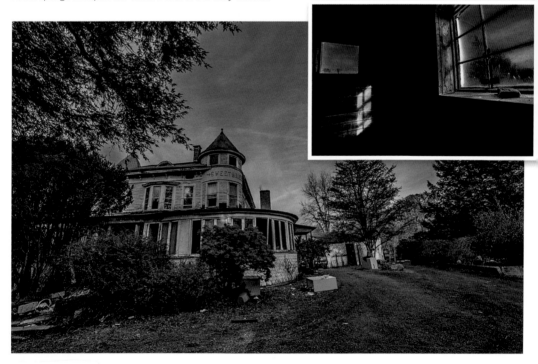

The beauty of the Victorian Sweetbrier house is marred by the trash and junk littering the yard—nothing clean about a remodel, I suppose.

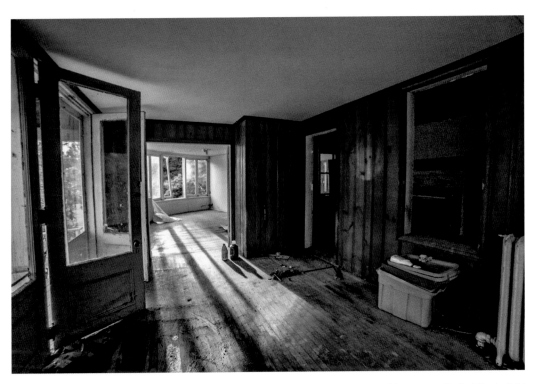

Baroque-influenced Eenfilade was common for the period into the Victorian era. You can see the building's slight curvature and know where the affordable strip floors might be salvageable.

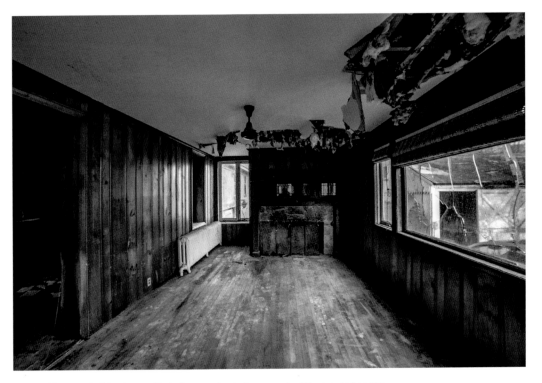

The wood of the long enfilade has survived where much of the house has not.

12

WILD BILL'S NOSTALGIA CENTER, MIDDLETOWN

"Do You Still Think of Me?"

William Ziegler, a.k.a. Wild Bill, was a hippie-turned-businessman-turned-destination guru. Saving and scraping, Bill eventually bought a defunct dairy farm and a 1940s nightclub called Club Vasques frequented by the Mob. He would laugh when he told the story of the long-timers in town, saying, "Don't dig around too much, Bill; you never know what you might uncover there."

The former nightclub hosted a variety of talent from Frank Sinatra to Tony Bennett and various mobsters from the Genovese and Gambino crime families, though none were as famous as Henry Hill. Henry, featured in Martin Scorsese's *Goodfellas*, frequented the Vasques Nightclub and even returned for a brief visit at the behest of his then-girlfriend. Hill visited a few times to reminisce or walk through to see recent additions to Wild Bill's, even planning to do a movie viewing and book signing, but Henry passed in June 2012.

In Bill's eclectic style, he painted the building with rock stars, horror monsters, and folk heroes. The site grew and would continue to grow with Bill bringing in a haunted funhouse from Old Riverside Amusement Park. Sculpture became a big part of the landscape. Wild Bill's Nostalgia Center's property boasted the world's largest jack-in-the-box—a bobbing clown head, slowly, mechanically appearing and disappearing inside the giant silo. It is only fitting that clowns pop up throughout the property as Bill's grandfather was a circus clown for Ringling and Barnum and Baily Circus. Grandpa was also an unsung hero slicing holes in the canvas tent for escapees in "The Day the Clowns Cried," the Hartford Circus fire from 1944 that killed 167 people and injured more than 700.

Bill played a murderous carney clown in a movie called *Pinwheel*. A concrete sculpted clown monster, reminiscent of the creature in the movie *Poltergeist*, reared its head one day on the grounds. Whether engulfing the shop's entryway or a

distorted figure slung over a carnival ride car like a discarded body, clowns would be a reoccurring theme. Pterosaurs to cows, fiberglass figures have a graveyard out back next to the endless inventory trailers that the shop could not house.

Bill and his family incorporated events into the store's repertoire, from concerts to an annual piano burning. The last project was the Pretzel Amusement's dark ride, Laff-in-the-Dark, which they had procured from Beechland Amusements in Staten Island and were trying to refurbish. A dark ride sometimes called a "ghost train" is an indoor amusement ride on which passengers ride aboard guided vehicles that travel through specially lit scenes that typically contain animation, sound, music, and special effects. I met the carny, Chuck Burnham, who was doing the repairs after letting me come out to do night photography on the property. Burnham, to be close to the project, resided out the back of the building. The restoration was to be done from reclaimed wood, mainly from the property itself, with Chuck's artistic vision as Bill was proud that it would not be a typical ride of today—plastic and formulated. I do not know what happened to the restoration, but eventually, Bill turned the ride housing into a video game, record store, library filled with taxidermy called Funhouse Record and Books.

Bill passed at the age of seventy in 2017, and the thirty-year business closed. His death left the store and its trailers of contents to his family, who sold it in 2018 to a nearby car dealership. Today, Wild Bill's remains a memory of a cool, artistic guy who just wanted to give a little of the weird and wonderful to people, as the car lot that purchased it started demolition in February 2021.

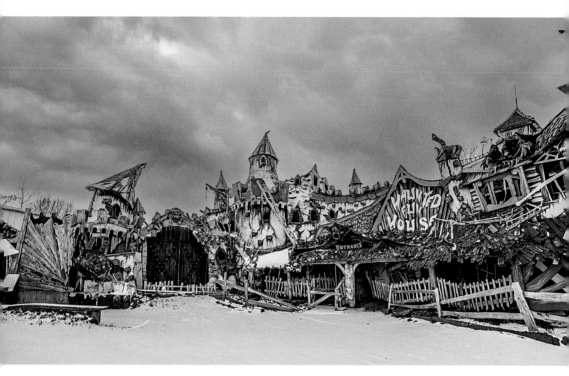

Wild Bill's Nostalgia Center's Funhouse and Laff-in-the-Dark ride from the front.

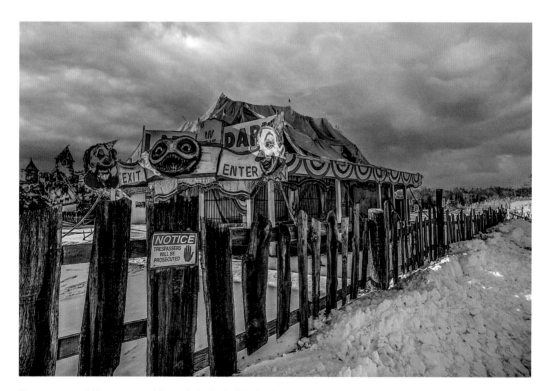

Trespassers would be prosecuted if caught in the Laff-in-the-Dark, but Bill would not hesitate to just show it to you.

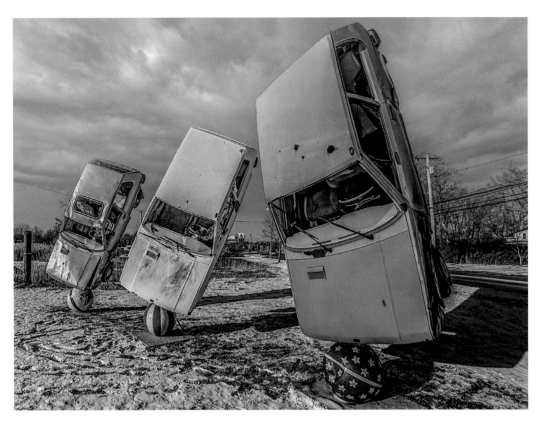

Joe McCarthy and Peter Albano's 1980's Yugo's balancing on balls, titled "I'd Go Where Yugo Stanley Marsh 3," ran parallel to the road to please the passers-by.

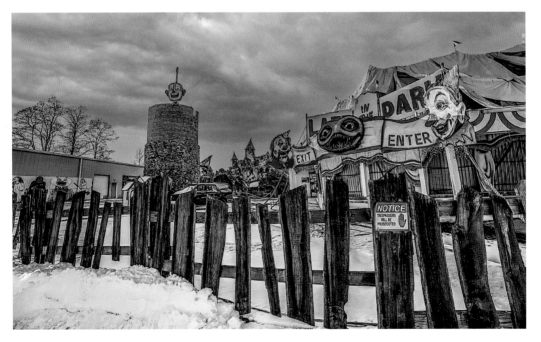

The world's largest clown jack-in-the-box sits aside the tarped Laff-in-the-Dark, waiting for the day fairgoers would arrive.

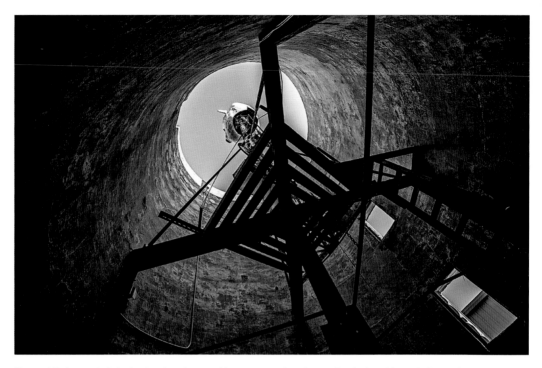

The world's largest jack-in-the-box from its guts. Here you can view the mechanical workings of what makes him rise, fall, and slowly move his head as if to watch you on the grounds.

Here we see a felled type of spun glass pterosaur out in the back of Bill's by his storage. When they were closing, this was the one thing I went back for in hopes of purchasing it. Admittedly, it was a little chaotic. I still think of this sad creature lying in the snow.

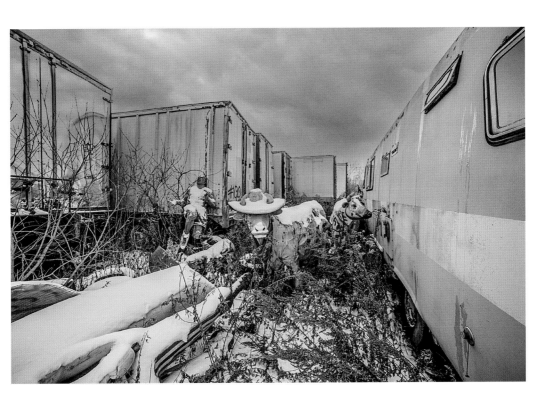

Above: Nosey glass thread cows and Michael Jordan hang out behind the trailers like a couple of spoiled kids up to no good.

Right: A close-up shot of the demon clown face of the newest sculpture added to Wild Bill's. Rebar horns curl out of its brow, and it looks like it is almost regretting what it is going to do to you—it is going to do it any way but maybe feel bad about it.

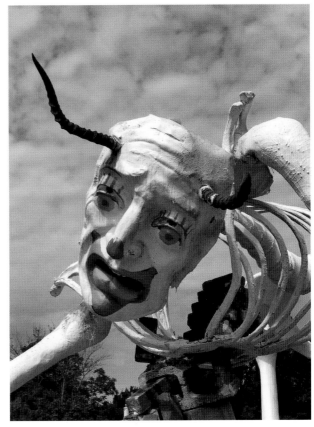

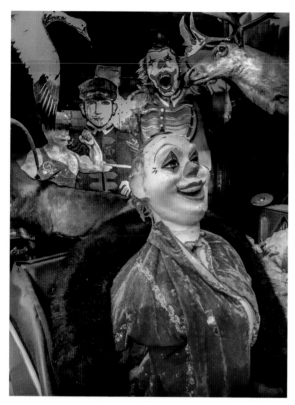

Here we have a clown laughing in its mink stole and red velvet dress as it drives you to your death. Thanks for the nightmares, Wild Bill.

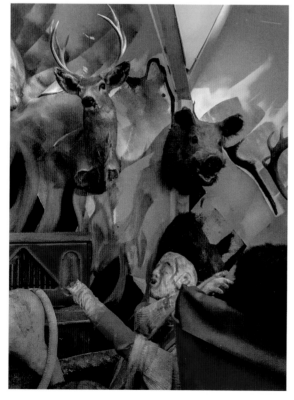

Boar, deer, and disfigured circus doll creepily shroud the barrel organ. Perhaps this beauty was an animated dancer while a monkey was an organ grinder.

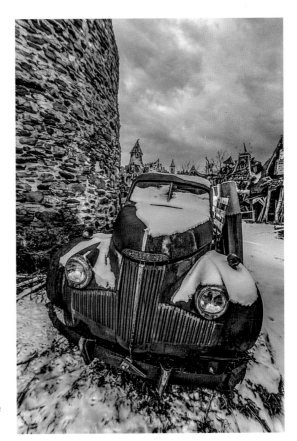

Right: Next to the jack-in-the-box's tower, a Studebaker skeleton acts as a lean-to for a couple of wooden coffins.

Below: The original Staten Island Laff-in-the-Dark ride's vintage cars sit waiting to be redone. Notice the intertwined snakes on the outside of the car's right panel.

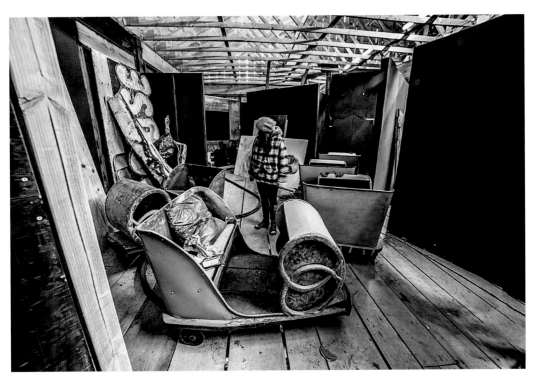

13

PLEASURE BEACH, BRIDGEPORT

"I Lose Your Hands Through the Waves"

Pleasure Beach was once Connecticut's biggest ghost town. P. T. Barnum had dreams of developing the island into another Barnum creation but unfortunately died in 1891, shortly before the park opened. Cashing in on an already big draw from Barnum's interest, two liquor dealers from the area bought the island in 1889, deciding to turn the 37-acre sanctuary into a destination amusement park.

The park changed hands continuously due to lousy luck, fires, to fickle visitors and held names such as Steeplechase, Sea Breeze, and Pleasure Beach.

The Stratford side of the island had an estimated forty-five cottages with renters and residents alike. One could own or lease a home there on the condition that the land would always be considered public land.

A bridge connecting the island to Bridgeport made it easy to access by car and foot. The Brinckerhoff Ferry would carry visitors from a downtown Bridgeport dock. It was said, in the 1930s, Pleasure Beach was so "hoppin'" that there could be anywhere from 30,000 people on the island on holiday.

Fires plagued the island seven times from 1953 until 1996. The first fire was in 1953; it was sparked by faulty wiring. The fire damaged some of the rides and attractions, namely the Sky Rocket rollercoaster, concessions, the funhouse, and the penny arcade. A cigarette started the 1957 fire on the bridge; this fire resulted in the auctioning off of rides and new proposals for a casino. The fire of 1962 destroyed the auctioned-off rollercoaster as 1965's fire destroyed a portion of the bridge. The fire of 1972 claimed the midway, and 1973's fire ended up leveling the dance pavilion. Once the pavilion was gone, there was no coming back for the destination getaway.

In 1996, Vandals burned the boardwalk from the bathhouse to the beach and the main bridge, leaving permanent access to the island unavailable for residents. People

dropped everything as they evacuated. Walking through the abandoned village, it looked like one of the Roswell setups, with food still on plates as homeowners had dinner places set, TVs and music still going, to sprinkler systems watering the yards. Residents were forced by eviction to permanently leave in 1997 as the cottages were private but on public land. Conspiracy theories of eminent domain and purposeful damage floated through the cities, and some fought and sued the city to no avail. Pleasure Beach would be the "Million Dollar Playground" no more.

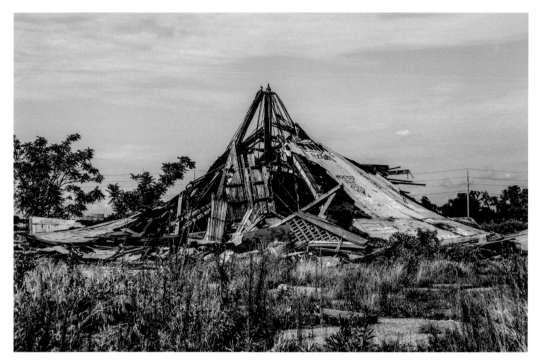

The tiniest bird perches atop the once-famous Pleasure Beach Carousel, which is now in shambles.

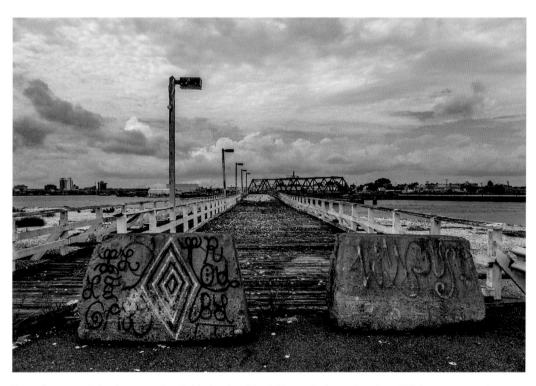

Two yellow concrete barriers are put up to block entry of the bridge to the burned sections. This has not stopped anyone, especially not the shorebirds that have covered it in scrapped oyster shells and faeces. This was probably once pretty lovely to walk along, with the lights and waves rushing in the background.

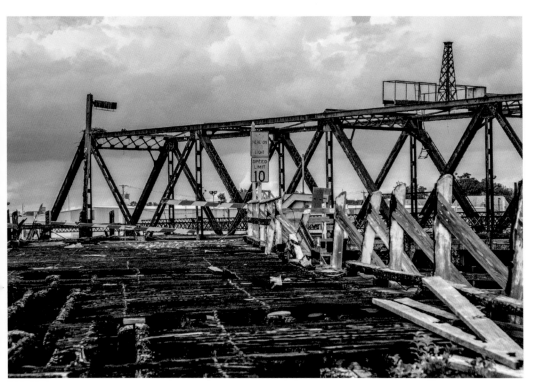

Speed limit signs and driving instructions still stand as if anyone would travel over the disintegrating bridge again.

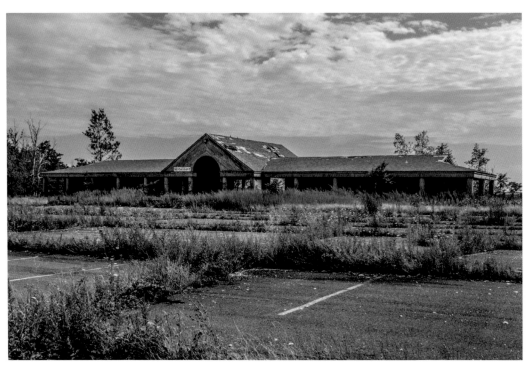

A wide shot of the restaurant, pavilion, and front parking lot, showing how many people could be accommodated here.

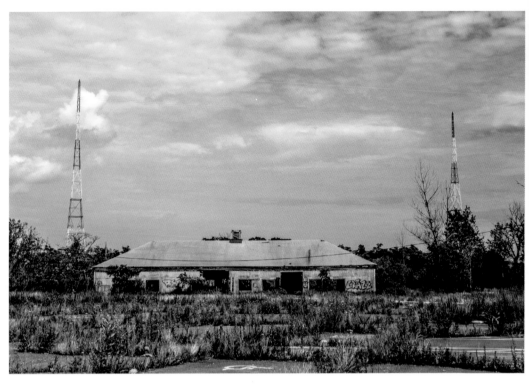

The radio towers, huge parking lot, and back construct on the sanctuary made for a loose shot.

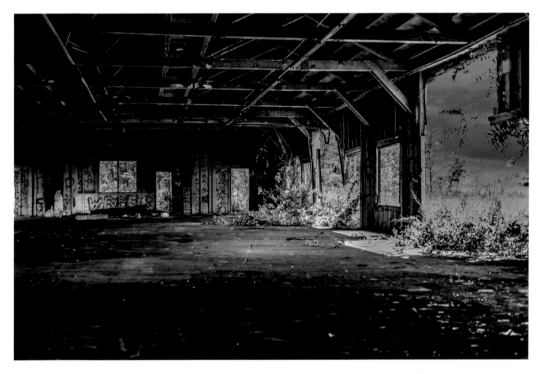

Once filled with tables, families, and the smell of seafood, the restaurant now provides shelter from the elements to the numerous deer, fox, coyote, and raccoon that live on the island.

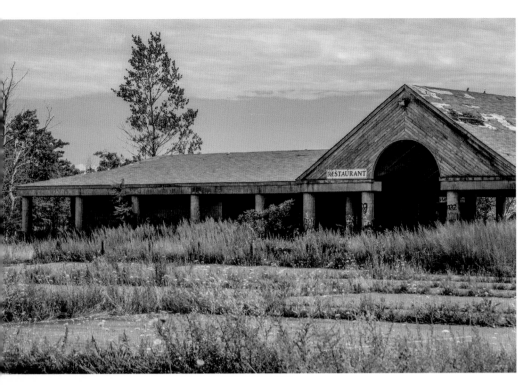

This is the once-booming restaurant that served up heaping oysters and clam belly for unheard-of low prices.

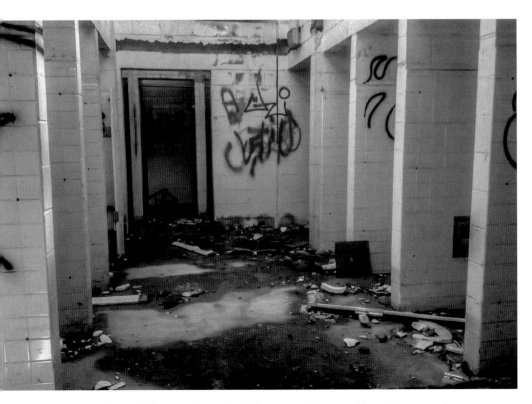

Yellow square tiles are all that remain from the bathrooms and showers of the restroom complex.

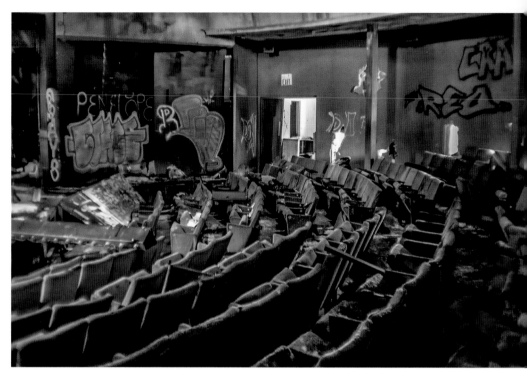

Poorly done graffiti and scribbles accent the already dingy, smelly frame that was the thriving epicenter of nightlife.

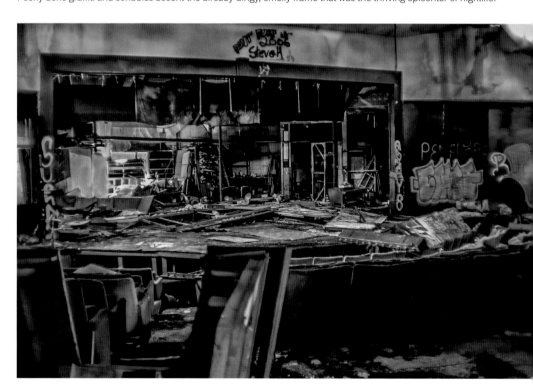

What a mess that is left. A view of the stage from mildewed fetid seating. If you have ever smelled sea water damage in an old hotel or rug, you can imagine what the theater smelled like.

Props and storage. Years of wood, wall, and shelving stacked backstage have been touched by fire, water damage, vandalism, and age.

The backstage of the theater looks wet, charred, tattered, and in a mess, as if the occupants tried to escape a fire.

BIBLIOGRAPHY

Archaeology of a Dark Ride," *academia.edu*

Bloom, L., "The Sun Sets on the Sunrise Resort," *The New York Times* (Moodus, CT: 2008)

Bendici, R., "Undercliff Sanatorium, Meriden," Damned Connecticut (Meriden, CT: 2012)

Cavanaugh, J., "Plan to Revive Pleasure Beach," *The New York Times* (Bridgeport, CT: 1988)

Ciprus, L., "Phantom Mobsters Nightclub Clowns and Yugo's, The World that is Wild Bill's," *Ink CT* (Middletown, CT: 2015)

Condon, T., "Hartford Circus Fire; Day of Panic, Heroes," *Hartford Courant* (Hartford, CT: 2014)

Connecticut History, "A Unique Island Attraction in Bridgeport," Connecticut History Organization (Bridgeport, CT: 2019)

Crevier, N., "Richard F. Gretsch, Sr.," *Newtown Bee* (Danbury, CT: 2010)

CT Government, "About the Southbury Training School," CT.gov (Southbury, CT: 2021)

CT State Library, "Mansfield Training School Records', Connecticut State Library Archives" (Mansfield, CT: 2021)

Dempsey, C., "Possible Arson Fire Destroys Vacant Newtown Mansion," *Hartford Courant* (Newtown, CT: 2016)

Dempsey, C., "Waterbury Man Sentenced to 55 years in Holy land Murder," *Hartford Courant* (Waterbury, CT: 2011)

Endicott, S., "The Ocean; the Sun and the Moon," The Bravery /Amalfi Coast Music (Nationwide: 2007)

EquineNow, "Lion Hill Farm," *Equine Now* (Easton, CT: 2021)

Gioiele, B., "Shelton Star Pin factory fire; 'We lost a part of history," *CT Post* (Shelton, CT: 2020)

Hamilton, E., "The Toll: Suffocation, Drowning, Choking, Burns," *Hartford Courant* (Mansfield, CT: 2012)

Historic Buildings of Connecticut, "Mansfield Training School and Hospital: Superintendent's House 1870/1931', Historic Buildings of Connecticut" (Mansfield, CT: 2019)

Historical Society of Easton Connecticut,"Easton House Sweetbriar *c.* 1900', Historical Society of Easton, CT," (Easton, CT: 2019)

Holy land USA, Holy Land USA' Holy Land USA Official Website (Waterbury, CT: 2021)

Hopkins, A., "Lost and Forgotten: Sunrise Resort," *The Patch* (Moodus, CT: 2013)

Howe, E., "Connecticut Pin Makers," Connecticut History Organization (Shelton, CT: 2017)

Milone & MacBroom, "Southbury Training School Future Use Study," Southbury CT Organization (Southbury, CT: 2018)

Nanevski, D., "Pleasure Beach: Connecticut's largest ghost town brought back to life after almost two decades of abandonment" *Abandoned Spaces* (Bridgeport, CT: 2017)

NYC Gove Parks, "Steeplechase Park," New York City Government Parks official website (NYC, NY: 2021)

O'Nan, S., "The Circus Fire; A True Story of an American Tragedy," *Anchor Books* (Avon, CT: 2001)

O'Rourke, Representative, "Connecticut Department of Government Administration Meeting Notes," *CGA CT GOV* (Meriden, CT: 2004)

Pilon, M., "Well-known Middletown retail landmark, vacant since 2018 sold to neighboring auto dealer," *Hartford Business* (Middletown, CT: 2021)

Ramunni, K., "Permit denial may doom Shelton's Chromium Processing Co.," *CT Post* (Shelton, CT: 2010)

Rockledge, C., *"Norwich State Hospital," Arcadia Publishing* (Preston, CT: 2018)

Shannahan, J., "Seaside Sanatorium; Seaside Regional Center," National Register of Historic Places (Waterford, CT: 1995)

State Tuberculosis Commission, "Report of the State Tuberculosis Commission for the Period Beginning October 1, 1918 to June 30, 1934 Internet Archive," uploaded by the University of Toronto (Hartford, CT: 2008)